WINTER

Published on the occasion of the exhibition WINTER

February 1 through March 16, 1986

Hood Museum of Art

Dartmouth College, Hanover, New Hampshire

WINTER

With Essays by Donald Hall and Clifton C. Olds

Hood Museum of Art, Dartmouth College

Distributed by University Press of New England

Hanover and London, 1986

UNIVERSITY PRESS OF NEW ENGLAND

Brandeis University University of Connecticut University of Rhode Island
Brown University Dartmouth College Tufts University
Clark University University of New Hampshire University of Vermont

Printed in Japan

LIBRARY OF CONGRESS CATALOGING IN PUBLICATION DATA
Main entry under title:

Winter : published on the occasion of the exhibition,
 Winter, February 1 through March 16, 1986, Hood
 Museum of Art, Dartmouth College, Hanover, New
 Hampshire.
 Includes index.
 1. Winter in art—Exhibitions. 2. Art—Exhibitions.
I. Hall, Donald, 1928– . II. Olds, Clifton C.
III. Hood Museum of Art.
N8262.5.W55 1986 760'.074'01423 85–15767
ISBN 0–87451–354–5
ISBN 0–87451–355–3 (pbk.)

This exhibition has been made possible by gifts from the William B. Jaffe and Evelyn A. Jaffe Hall Endowment Fund; Jane and Raphael Bernstein, the Bernstein Development Foundation; and Vermont Castings, Inc.

Cover/jacket illustration: Childe Hassam, *Late Afternoon, New York: Winter,* 1900, The Brooklyn Museum, Dick S. Ramsay Fund (cat. no. 47).

beauty, winter readily finds its way into the imagery of cultures for whom art is didactic and encyclopedic rather than esoteric and selective. In agrarian societies for whom the cycle of the seasons is central to the issues of life and death, the interrelationship of Time, Nature, and God provides a major focus of religion and the arts that serve religion. And since the mind expresses its crucial concerns in symbols of the inevitable, it is hardly surprising that many cultures should create images that personify and even deify the seasons. Prehistoric art and the art of nonliterate cultures lie beyond the scope of this exhibition, but in considering "primitive" personifications of the seasons, one could cite the Kachina snow dolls of the Pueblo people, who believe that early in their history, their society was divided into Summer people and Winter people (the association of seasons and human types has its parallel in the Western theory of the Four Temperaments). Winter deities or spirits must have played a major role in many northern cultures for whom natural phenomena were supernaturally generated, and the vestiges of those beliefs still exist: witness the survival of Jack Frost in our own folklore.

However, whereas modern attitudes toward winter may reflect concepts as old as the human mind, the more immediate sources of our seasonal imagery lie in the art of the Hellenistic world and its Christian sequel. Solar worship—central to so many ancient religions and tangential to many modern ones—inevitably involves the worshiper in a concern for the annual weakening and strengthening of the sun. Thus winter takes its place beside the other seasons as a time and condition that must be addressed, propitiated, and, in spite of its negative associations, *celebrated*, for it is in the winter that the sun dies and is born again. Constantine's decision to establish December 25 as the date of Christ's nativity unites the Roman festival of the Unconquered Sun—*sol invictus*—with the solar imagery of the Old and New Testaments and the Christian concept of death and resurrection. The implications for Western art and literature were momentous. In the prayers of Erasmus, the landscapes of Pieter Bruegel the Elder, the poetry of Shakespeare, the cantatas of Bach, the folktales retold by the Brothers Grimm—in every chapter of the history of Western thought one finds winter serving as a metaphor, with or without specifically Christian meaning, for death and rebirth. Although the specific iconography of winter, to which we shall now turn, is as much physical as metaphysical, it is difficult to find

an image of winter in which there is not at least a hint of this elemental association.

Winter: An old female, in long Mantle, furr'd; her Head covered; of a doleful Aspect; her left hand wrap'd in her Garment, holding it up to her face With Tears in her Eyes; a wild Boar, and a Flame-pot, by her Side; which Shews the cold Season.

Cesare Ripa, Iconologia
(from the first English translation of 1709)

Among the earliest references to winter in European art are the calendar illustrations of the Hellenistic world, where the months are represented by appropriate images of human activity, and Roman sculpture and mosaics in which the Four Seasons are personified.[3] Although there is little consistency in the representation of the months, certain physical types and activities appeared frequently enough to establish patterns that have survived into our own era, their persistence partly explained by their appropriateness and, indeed, by their inevitability. In the lands under discussion, winter is *cold*, and so the Roman monuments in which winter months are illustrated often represent December, January, or February as a man or woman wearing heavy robes, cloaked against the winter wind. Such a figure was also the standard personification of the winter season in Roman art, and it continued to serve that function in Western art for the next two millennia. In accordance with Cesare Ripa's prescription, men and women huddled in heavy cloaks represent winter in works as diverse as sixteenth-century Italian bronzes and seventeenth-century English ceramics. Jean-Antoine Houdon's famous statue of a shivering young woman (fig. 1) introduces an erotic factor that is foreign to antique prototypes, but the figure huddled within its inadequate shawl is clearly the direct descendant of the old Roman personification of winter.

[3] The standard source on the iconography of the months and seasons in ancient art is Doro Levi, "The Allegories of the Months in Classical Art," *The Art Bulletin* (1940), 23:251–91. Other sources one may consult for medieval and Renaissance images of the months and seasons include Emile Mâle, *The Gothic Image* (New York, 1972); and Raimond van Marle, *Iconographie de l'art profane au moyen-âge et à la Renaissance* (The Hague, 1931–32).

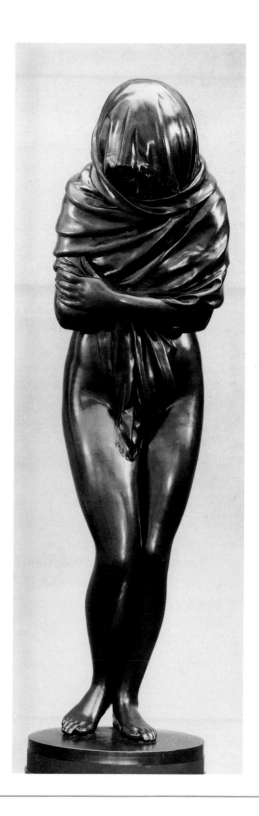

Figure 1. *Jean-Antoine Houdon, French, 1741-1828*
LA FRILEUSE (WINTER), 1787
Bronze, height 57 inches
The Metropolitan Museum of Art, Bequest of Kate Trubbe Davison, 1962 (62.55)

Houdon's work admirably meets the challenge that often faces the painter or sculptor who must attempt to make visible the invisible, in this case the phenomenon of cold. The artists of the Middle Ages often met this challenge by emphasizing the more easily envisioned antidote to cold: heat in the form of fire. Time and again on the pages of medieval manuscripts or the facades of Gothic cathedrals, the month of January or February is represented by a man or woman warming hands or feet at an open fire, an image that finds its most memorable interpretation in the famous February miniature from *Les Très Riches Heures du Duc de Berry* (fig. 2). Here in a painting of ca. 1415, the Franco-Flemish artists known as the Limbourg Brothers show us peasants hoisting their winter garments to warm themselves at the hearth of a rustic farmhouse, while in the bleak winter world beyond its flimsy walls, men cut and deliver the wood that will feed such fires. (We will meet these woodcutters again in the winter landscapes of America.) In this earliest of all extant winterscapes, we have left behind the world of personification and have entered the realm of exemplification, but this, too, has its origins in the art of antiquity. In fact, in most of the ancient calendars the months were represented less often by symbol and metaphor than by examples of seasonal activity. Among the most frequently represented labors of winter were the hunting of wild game and the slaughter of pigs, and scenes showing these two activities would continue to surface throughout the next two millennia of winter imagery. In the *Chronograph of 354 A.D.*, an illustrated Roman manuscript known to us through the medium of a Carolingian copy, February is described as a figure "wrapped in a blue mantle, who sets out to catch the birds of the marshes."[4] This hunter becomes an enduring reference to the winter season. Not only does he appear often in subsequent representations of February, but he also personifies winter in many versions of the Four Seasons, sometimes holding a brace of birds, sometimes a hare. In the so-called Season Sarcophagi of Imperial Roman origin, he loses his winter vestments and takes on the appearance of a nude *genius tempestae*, but he still displays a brace of wild birds (fig. 3).

The association of winter and hunting lives on into the Renaissance, when Pieter Bruegel the Elder places hunters and hunting dogs in the foreground of what is surely the most famous winter landscape in West-

[4]Levi, p. 255.

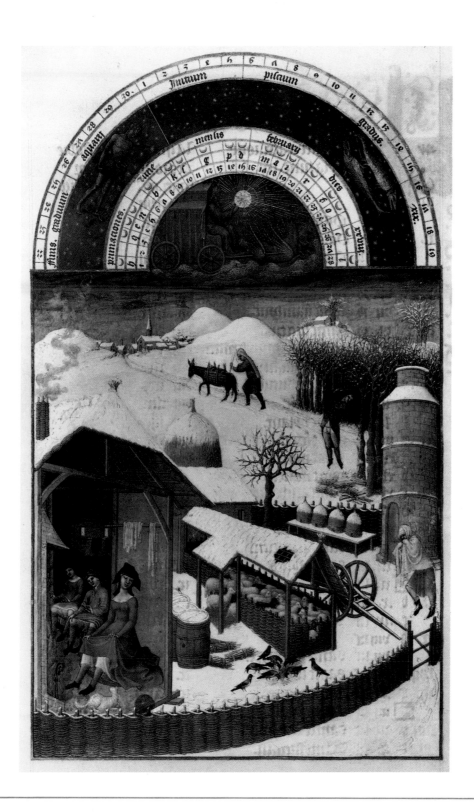

Figure 2. *Limbourg Brothers, Flemish, d. 1416?*
FEBRUARY, from *Les Très Riches Heures du Duc de Berry*, 1413–16
Tempera on parchment, 8⅞ × 5⅜ inches
Musée Condé, Chantilly, France
(In all measurements height precedes width. Dimensions for works of art on paper refer to the size of the plate or image rather than to the support.)

ern art: the painting in Vienna known as *The Return from the Hunt* (fig. 4). Moreover, Bruegel honors another ancient tradition by showing us, in the lower left quadrant of the painting, a country tavern before which peasants tend a roaring fire. The fire itself is a traditional element in winter iconography, as we have seen, and Bruegel employs it here to express the strength of the winter wind. But of even greater interest is the activity around the fire: the peasants are using flaming sheaves of straw to singe the bristles from a recently slaughtered pig. The killing and preparation of pigs for the religious feasts of December and January is an activity that often represents those months in ancient and medieval art; and, in fact, the personification of winter on Roman sarcophagi is sometimes accompanied by a boar (fig. 3). The image persists throughout the Middle Ages, appearing in astronomical calendars of the ninth century, in French sculpture of the thirteenth century (the slaughter of

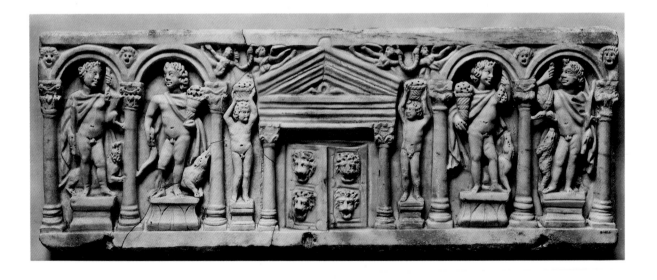

Figure 3. *Roman*
FRONT OF A CHILD'S SEASON SARCOPHAGUS OF THE
ASIATIC COLUMNAR TYPE, 290–300 A.D.
Proconnesian marble, 16¾ × 45½ inches
The Metropolitan Museum of Art, Rogers Fund, 1918 (18.145.51)

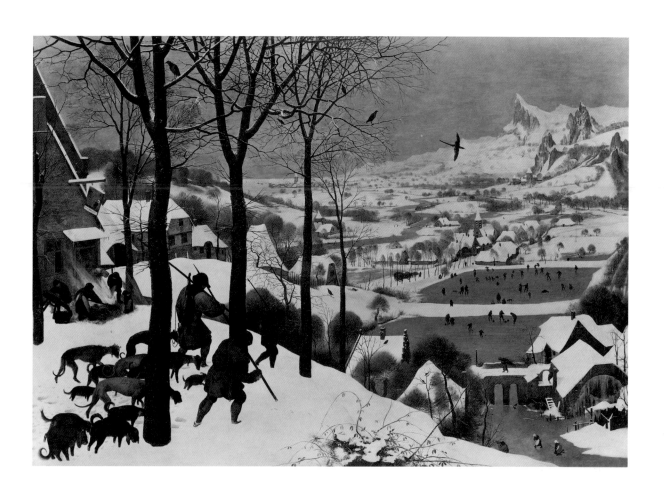

Figure 4. *Pieter Bruegel the Elder, Flemish, 1525/30-1569*
THE RETURN FROM THE HUNT, 1565
Oil on panel, 46 × 63¾ inches
Kunsthistorisches Museum, Vienna

pigs signifies the month of December on the portals of the cathedrals of Paris and Reims), and on the calendar pages of late medieval books of hours. On the pages of *Les Très Riches Heures du Duc de Berry*, the slaughter of pigs and the hunt are in effect combined, for the artists represent the month of December with a scene of hunters bringing down a wild boar (fig. 5). Cesare Ripa included a boar as one of the attributes of winter in the passage cited previously, and as late as the eighteenth century, Francisco Goya recalled this motif in his chilling study of Spanish peasants bracing themselves against a wintry blast and leading a donkey whose burden is a dead boar (fig. 6).

Although Goya's painting shows the theme of hog slaughter near the end of its iconic life, the winter hunt still retains much of its appeal. William Sidney Mount's *Catching Rabbits (Boys Trapping)* (cat. no. 23) is a lighthearted American sequel, and Rockwell Kent's *The Trapper* (cat. no. 57) is an even more obvious descendant of the ancient personification of winter. Whether Kent had any such antecedent in mind is doubtful (the scene is set just outside Kent's own cabin door in the area of Arlington, Vermont), but his painting conjures up a host of old associations—the weary hunters of Bruegel's *Return from the Hunt*, the melancholy of Ripa's description of Winter, and even the elegiac conventions of ancient Greek poetry:

> Naiads and chill cattle-pastures, tell
> to the bees when they come on their
> springtide way, that old Leucippus perished
> when out trapping scampering hares on a winter night . . .
>
> *Anonymous Greek epitaph (translated by J. W. Mackail)*[5]

———————————

Art historians often refer to the seasonal *exempla* of ancient and medieval calendars as "Labors of the Months," but not all the activities chosen to illustrate ancient and medieval calendars are laborious in the strict sense of the word. In fact, as a period of feasting and revelry—the season of the Roman *saturnalia*—winter was often viewed as a respite from labor. This idea persisted long after pagan feasts had given way to Christian festivals. While the hunt and the slaughter of pigs retained

[5] *Select Epigrams from the Greek Anthology*, ed. and trans. J. W. Mackail (London, 1911), p. 266.

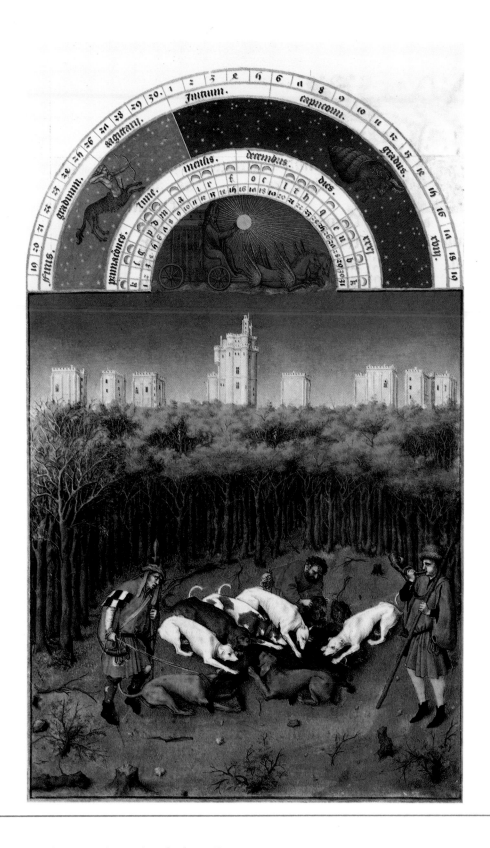

Figure 5. *Limbourg Brothers, Flemish, d. 1416?*
DECEMBER, from *Les Très Riches Heures du Duc de Berry*, 1413-16

Tempera on parchment, 8¾ × 5¼ inches
Musée Condé, Chantilly, France

their significance well beyond the medieval period, the winter feast competed with these images, emerging in the sculpture of the Romanesque and Gothic periods. (The feast represents the month of December at Vézelay, St. Denis, and Chartres; and the month of January at Arezzo, Ferrara, and Amiens.) It is ironic, but not really inappropriate, that these Christian banqueting scenes are sometimes presided over by the pagan deity Janus, the two-faced god of beginnings who, as I have indicated, symbolized the turn of the year and the transition between past and future. Extant Hellenistic calendars do not illustrate this figure, but he appears often enough in ancient calendar texts to suggest that the image was once fairly common in Roman art. Medieval examples undoubtedly reflect these lost prototypes, which may have emphasized the old year as explicitly as did their medieval sequels. On the cathedrals of Chartres, Amiens, and Paris, Janus *bifrons* displays one youthful and one aged face, a didactic reference to past and future with parallels in the writings of Isidore of Seville and other medieval authors for whom pagan allegories were convenient foundations for Christian moralizing.

By the later Middle Ages, however, pagan allegory had given way to contemporary *exempla*. On the pages of the *Très Riches Heures*, for instance, the January feast is presided over by the Duke of Berry himself. As a festive antidote to the grim realities of winter, the banquet theme was persistently attractive, particularly to the artists and patrons of the sixteenth and seventeenth centuries. These later winter feasts bring the tradition full circle in some instances, including among the guests such figures as Bacchus, Comus, and other pagan gods of revelry (cat. no. 16). Even when the subject still retains its Christian meaning, as in the case of Baroque representations of the Epiphany feast, the scene is sometimes a raucous celebration worthy of the ancient *saturnalia*.

But just as Janus "can always see all things from both sides" (to quote the *Chronograph of 354*),[6] so winter pastimes were sometimes seen in a mixed light. A Dutch woodcut of 1498 (cat. no. 13) illustrates the dangers of ice skating by recording the disastrous fall of one Ludwina, a young woman of Schiedam whose tumble resulted in a bedridden life of physical affliction and spiritual ardor (the publication of the *Vita Lidwinae*, for which the print is an illustration, is associated with the proposal of her canonization). Given the medieval mind-set, this acci-

[6]Levi, p. 253.

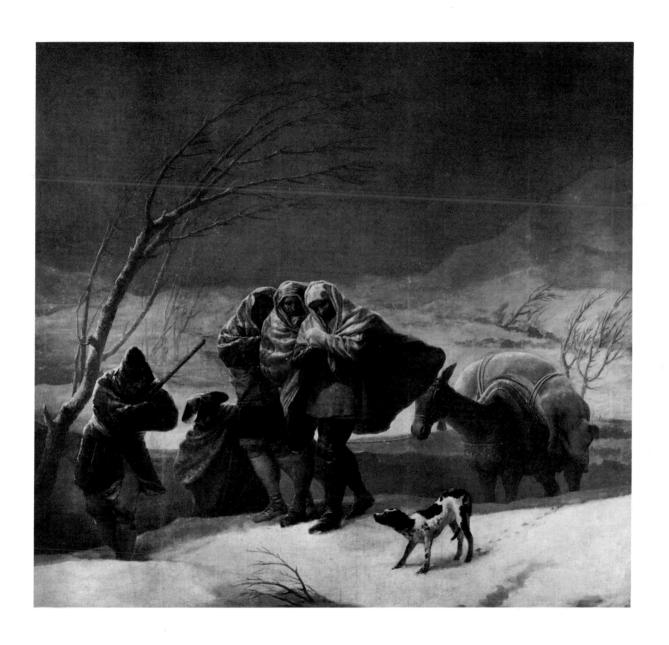

Figure 6. *Francisco Goya, Spanish, 1746-1828*
LA NEVADA (THE SNOW STORM), 1786-87
Oil on canvas, 103⅜ × 110⅜ inches
Museo del Prado, Madrid

dent was probably viewed as the fall of Pride, and its sequel the triumph of Humility. It is the sort of moralizing common to medieval and Renaissance interpretations of winter. One of Pieter Bruegel the Elder's most famous and most influential paintings represents the citizens of a picturesque Flemish village cavorting on a frozen river or canal: skating, spinning tops, playing hockey, curling. Unlike a number of Bruegel's winter scenes, the mood is a gentle one, with the apparently innocent activities taking place beneath a hazy, golden sky that seems to promise imminent relief from the rigors of winter. Given the seductive charm of the painting, it is small wonder that it inspired not only scores of copies (cat. no. 15), but a whole tradition of Baroque winterscapes. Such seventeenth-century Dutch masters as Hendrick Avercamp (fig. 7) and Aert van der Neer made their reputations on the basis of winter scenes derived from Bruegel's little panel, preserving the lighthearted spirit and closely modulated color scheme of the original while amplifying and complicating the human activity taking place on the frozen canal. What Avercamp and the other winter specialists of the seventeenth century overlooked or chose to ignore, however, is the ominous implication of Bruegel's work, an implication revealed by a close examination of the painting's details.

Although the painting is often given the innocuous title *The Skaters*, an alternative and more revealing title is *The Bird Trap*, a reference to the primitive device found in the lower right quadrant of the painting. A dilapidated wooden door has been propped up with a stick, and birds are pecking at grain scattered around and beneath it. A string runs from the stick to the window of a nearby building, and once a number of birds have gathered beneath the door, the unseen trapper will pull the string and crush his prey. In a recent study of the painting, Linda and George Bauer show that the bird trap is a traditional symbol of the wiles and temptations of the Devil, as expressed in literary and visual similes that derive from biblical sources and resurface in the art and literature of the later Middle Ages.[7] Once we remember the allegorical inflections winter acquires in the medieval period, the message of Bruegel's painting appears subtly stated but unmistakable: while Man is thoughtlessly amusing himself on the frozen canal, the Devil lies in wait. Indeed, the apparent warmth of the winter sky may well be Bruegel's way of sug-

[7] Linda and George Bauer, "The *Winter Landscape with Skaters and Bird Trap* by Pieter Bruegel the Elder," *The Art Bulletin* (1984), 66:145–50.

gesting that the villagers are both literally and morally skating on thin ice. This line of interpretation receives confirmation from another of Bruegel's winter scenes: a study of skaters disporting themselves before the Gate of St. George in Antwerp. (The subject is represented in this exhibition by an engraving [cat. no. 14] after Bruegel's original drawing.) Once again, the scene appears to involve nothing more consequential than winter revelry, with various figures demonstrating their prowess or their clumsiness in contending with the slippery surface of the frozen canal. However, an inscription on the second state of the engraving for which Bruegel's design was the model refers to the "slipperiness of human life" (*lubricitas vitae humanae*). The concept survives

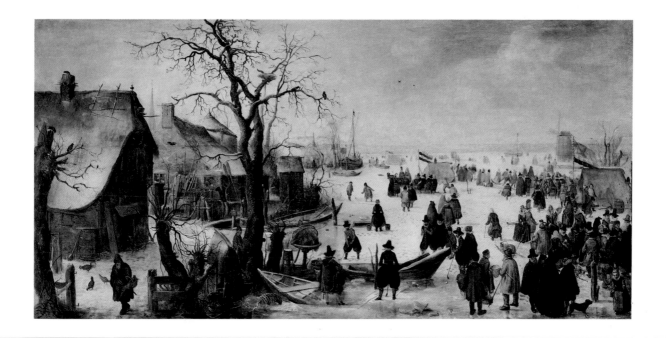

Figure 7. *Hendrick Avercamp, Dutch, 1585-1634*
WINTER SCENE ON A CANAL, ca. 1615
Oil on panel, 18⅞ × 37⅝ inches
Toledo Museum of Art, Gift of Edward Drummond Libbey

well into the seventeenth century, as the Bauers demonstrate by quoting George Wither's epigram for an emblem of a figure walking on ice:

> We are all *Travelers*; and all of us
> Have many passages, as dangerous,
> As *Frozen-lakes*; and Slippery-wayes, we tread,
> In which our lives may soon be forfeited,
> (With all our hopes for life-eternall, too)
> Unlesse, we well consider what we doe.[8]

In short, winter becomes a metaphor for the precariousness of life and man's spiritual vulnerability, and it is a trope with history behind it. Since winter is the darkest and coldest season of the year, Christian writers who associated Christ with the sun, and God's love with summer heat, naturally saw winter as the seasonal reminder of sin and the exile from grace. So Rabanus Maurus, the ninth-century theologian and encyclopedist, argued that winter suggested the period of darkness before the coming of Christ; and Dante, whose Paradise is a place of burning love, consigned the greatest villains of history to a Hell of bitter winds and eternal ice. Because the medieval mind saw in all aspects of the natural world the manifestation of God's will, it would have been virtually impossible to have ignored the "meaning" of winter: that the dark, cold, sunless skies and sterile landscape inevitably signified human depravity and its mortal consequence. When we describe a sudden conversion to more charitable ways as "a melting of the heart," we employ a figure of speech with Dickensian associations, but also with roots deep in the thought and art of the Middle Ages.

As it happened, the skaters of Bruegel's paintings and drawings were to glide innocently into subsequent generations of art history, oblivious to whatever moral or natural disasters may be implied by their recreation. In seventeenth-century depictions of the four seasons, winter is often represented by a skating scene (cat. no. 17), and the Flemish and Dutch painters who specialized in winterscapes inevitably made skating and other icy sports the principal activities of their human figures. There are no malevolent overtones in these works, just as there is nothing but sympathetic goodwill in nineteenth-century American artists' renderings of the same subject (cat. nos. 21 and 27). Indeed, Gilbert Stuart's famous portrait of William Grant skating in Hyde Park (fig. 8)

[8] Ibid. The passage is taken from *A Collection of Emblems* (London, 1635), ed. John Horden (Mewston, Yorkshire, 1968), p. 153.

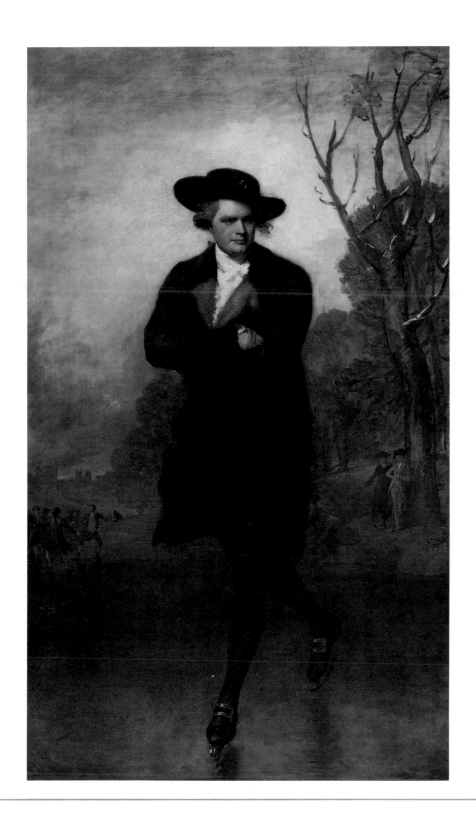

Figure 8. *Gilbert Stuart, American, 1755-1828*
THE SKATER (PORTRAIT OF WILLIAM GRANT), 1782
Oil on canvas, 96⅝ × 58⅛ inches
National Gallery of Art, Washington, D.C.; Andrew W. Mellon Collection

prompted an English critic to praise Grant's grace and "manly dignity," an appraisal that might have brought a cynical smile to the face of Pieter Bruegel, for whom skating and its potential disasters symbolized not grace but the Fall from Grace.

You must also seek to portray with
colours snow, hail, rainfall, frost,
rime, steaming, and dreary fogs, all
the things that are necessary to
depict melancholy winter days. . . .

Karel van Mander (1548–1606), The Painter's Book

Although the iconography of winter—its attributes and symbolic associations—is of primary interest to historians concerned with seasonal imagery in antique and medieval art, the student of landscape painting will focus upon the formal elements that begin to distinguish winter scenes in the first decades of the fifteenth century. When Pol Limbourg and his brothers contributed their calendar illustrations to *Les Très Riches Heures du Duc de Berry*, a new chapter in the history of landscape painting began, and as far as the winter landscape was concerned, it was the *first* chapter. I have commented on the miniature illustrating February in terms of its traditional iconography—peasants warming themselves at a fire, the cutting of firewood, a figure huddled against the cold—but it also stands as one of the first realistic landscapes of the modern period, and it is certainly the earliest surviving snow scene in Western art. It would be misleading, however, to credit the painters of the early Renaissance with the sympathetic response to winter we sense in the landscapes of later centuries. Outside of illustrated calendars and the paintings of Pieter Bruegel the Elder and his followers, snowy landscapes are in fact rare before 1600. However, beginning in the fifteenth century, northern European painters looked carefully at the natural world and, in line with evolving attitudes toward time and the cycles of life, recorded the changing appearance of the earth in ways that no medieval artist would have attempted. Acknowledging that the Nativity of Christ occurred in December and the Adoration of the Magi in early January, Hugo van der Goes set these events in landscapes whose leafless trees rise in dramatic silhouette against a chilly sky, a formal device that would become a stock item in the vocabulary of the winter landscapist

for centuries to come (cat. nos. 19 and 32). Bruegel employed the motif in his *Return from the Hunt*, and it has a modern sequel in the bare, bony trunks of Lawren Harris's *Above Lake Superior* (cat. no. 58) or in the delicate filigree of branches in Ralph Steiner's winter photographs (cat. no. 85). To remain for a moment with Bruegel's *Hunt*, it should be noted that the various components of this monumental landscape lived on in scores of later paintings devoted to the winter scene. The mill in the lower right corner of the composition, its wheel locked in an embrace of ice, recurs time and again in paintings such as Régis François Gignoux's *Winter Scene* (cat. no. 24); and the gathering and transporting of firewood, which Bruegel borrowed from the late medieval calendar pages, survives in the winterscapes of George Henry Durrie (cat. no. 25). (Such painters as Durrie, Gignoux, and John Henry Twachtman are American counterparts to the "winter specialists" of seventeenth-century Dutch landscape painting.) And as we have seen, Bruegel's hunters and skaters have a legion of descendants. One might argue that the recurrence of such details does not necessarily imply derivation, but in fact the great winter landscapists of the modern era have been well aware of the tradition initiated by Bruegel's paintings, if only through the hundreds of seventeenth-century sequels found in American and European collections. Even if we deal only with coincidental similarities, as is probably the case with Jasper Francis Cropsey's *North Conway, N.H.* (cat. no. 26) or Rockwell Kent's *The Trapper* (cat. no. 57), the striking kinship of these works to Bruegel's famous landscape underscores the durability of the genre.

Nature is never so lovely than when
it is snowing.

John Henry Twachtman (1853–1902)

As significant and interesting as are the various details and activities of these landscapes, the mood of a winter scene is established by two elementary if amorphous components: sky and snow. It has been justly stated that the real subject of seventeenth-century Dutch landscape painting is the sky, and when such masters as Jacob van Ruisdael or Aert van der Neer turned their attention to the winter landscape, they created skies that can chill the observer's blood. The black, turbulent clouds that

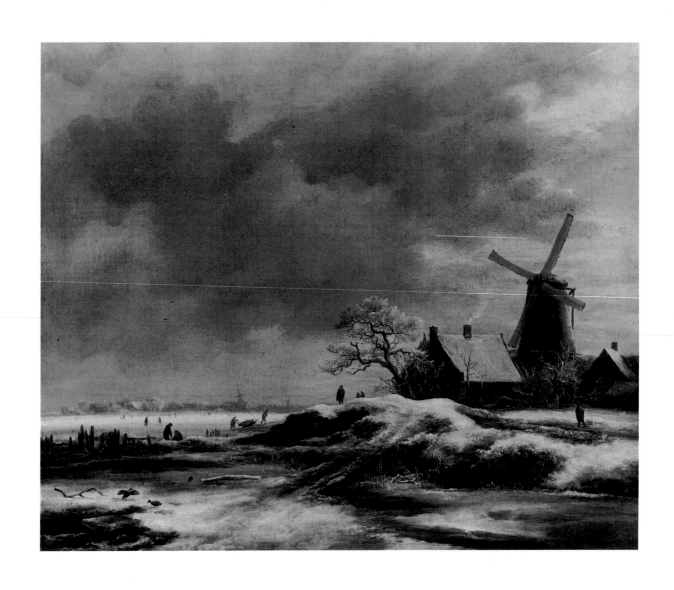

Figure 9. *Jacob van Ruisdael, Dutch, 1628/29-1682*
WINTER LANDSCAPE WITH A WINDMILL, ca. 1670
Oil on canvas, 14¾ × 18 inches
Fondation Custodia (collection of F. Lugt), Institut Néerlandais

dominate a Ruisdael composition (fig. 9) produce a mood of oppressive melancholy, a mood often reinforced by a shattered tree or a lonely windmill silhouetted against the sky. We look upon these paintings with eyes conditioned by the Romantic and Transcendentalist traditions of our own artistic and literary heritage, and our perspective may not be in line with the intent of the seventeenth-century artist or the interest of his patrons. And yet, that the crystalline charm of an Avercamp skating scene or the brooding grandeur of a Ruisdael winterscape reflect a heightened admiration for the shifting moods of nature and their psychological impact can hardly be questioned.

Snow is not so variable or dramatic as the winter sky, but it has the potential to reinforce the spirit of a landscape. Bruegel was probably the first Western artist to represent the actual fall of snow, which he does in his little panel of *The Adoration of the Magi in the Snow* (fig. 10). Without

Figure 10. *Pieter Bruegel the Elder, Flemish, 1525/30-1569*
THE ADORATION OF THE MAGI IN THE SNOW, 1567
Tempera on panel, 13¾ × 21¾ inches
Oskar Reinhart Collection "Am Römerholz," Winterthur, Switzerland

imputing a sort of Christmas-card mentality to Bruegel, there is no denying the aura of quiet intimacy these downy flakes contribute to the scene. It is exactly the mood generated by the snowfall in Robert Hills's *A Village Snow Scene* of 1819 (cat. no. 20), a work in which the forms and spirit of Bruegel's *Adoration* still resonate.

With Hills we return to the nineteenth-century landscape, whose gentle snowfalls persist in the works of our own era (witness Paul Signac's *Boulevard de Clichy* [cat. no. 45] or Willard Metcalf's *The White Veil* [cat. no. 48]). However, the winterscapes of the nineteenth century also include scenes of fearsome violence, particularly when seen against the rather pacific nature of eighteenth-century winter imagery. Considering the popularity of winter landscapes in the seventeenth century, the artists of the eighteenth seem surprisingly immune to the beauty or the drama of winter. The four seasons continue to appear in paintings, prints, and tapestries, and French masters such as Boucher have left us some charming if not very challenging studies of winter pastimes; but in contrast with the traditions of the Baroque era, winter seems rather tame in the age of the Rococo. With the nineteenth century, however, winter once more takes its place among the major categories of Western landscape painting, and it does so with a frightening intensity. Although no single explanation can ever account for the ebb and flow of a subject's popularity, it is clear that Romanticism promoted a fascination with the more dynamic and even threatening states of nature, and winter was such a state. As storm became a metaphor for any number of historical forces and human passions, Shakespeare's "furious winter rages" raged anew on the canvases of Europe and America. There were precedents for the winter storm motif. Poussin's *Deluge* is the winter component of his *Four Seasons*, possibly inspired by the traditional association of winter with death and rebirth, and the storms that abound in seventeenth-century Dutch marine paintings are sometimes winter storms. But it is William Turner, an admirer of both Poussin and Dutch landscape painting, whose paintings of snowstorms would introduce the modern era to the true rage of nature. Turner's *Valley of Aosta—Snowstorm, Avalanche and Thunderstorm* (fig. 11), which he painted after a trip to the Alps in 1836, is typical of the artist's desire to distill from his subject the very essence of nature's power. As in so many of Turner's paintings, this force is expressed as a vortex of elemental fury that both threatens and reduces to pathetic insignificance the human elements of

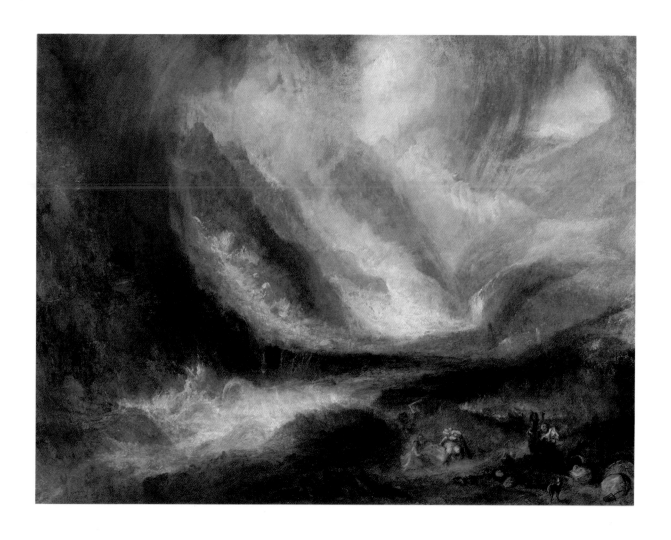

Figure II. *Joseph Mallord William Turner, English, 1775-1851*
VALLEY OF AOSTA—SNOWSTORM, AVALANCHE AND
THUNDERSTORM, 1836/37
Oil on canvas, 36⅜ × 48½ inches
The Art Institute of Chicago, Frederick T. Haskell Collection

his composition. John Ruskin argued that the real subject of Turner's paintings was death, and although such a categorical appraisal has not been popular with Turner's modern critics, the suggestion of merciless forces embodied in his swirling snow clouds lends validity to Ruskin's intuition. The long-standing association of winter and human mortality is the theme on which Turner composes a sublime variation.

Although Turner's maelstroms constitute perhaps the most dramatic winter images of the nineteenth century, it was in France and Germany that winter found its wider audience. There both conservative and progressive camps adopted the winter landscape—the former, as a setting for historical narrative or spiritual revery; the latter, as an end in itself. In the Impressionist fascination with winter we encounter a gentle paradox, for at the very moment that European artists began to leave the warmth and safety of their studios to paint out-of-doors, they also began to take an interest in a subject that was more comfortably painted in the studio. To be sure, the familiar spring and summer settings of the Impressionists outnumber their winterscapes, but there exist scores of canvases on which Monet, Sisley, and Pissarro recorded their perceptions of winter in France. Camille Pissarro's *Piette's House at Montfoucault* (*Snow*) (cat. no. 40) is a masterful study of wet, leaden snow, whereas Paul Signac's *Boulevard de Clichy* (cat. no. 45) shows us that moment when the snow begins to "stick" on city streets. Not surprisingly, it is Claude Monet who created the most memorable of Impressionist winterscapes, whether he was exploring the lights and shadows surrounding a haystack standing in a snowy field (cat. no. 42), or observing the breakup of the ice on the Seine during the severe winter of 1880 (cat. no. 41). For Monet, any and all weather conditions provided the opportunity to explore the effects of light upon solid and not-so-solid forms, and the snow and skies of his winter scenes are as rich and subtle in their colors as are the fields and waters of his summer scenes.

The Impressionist technique was particularly suited to the recording of a snowfall, as Signac's painting proves and as the Impressionists of America discovered with enthusiasm. Childe Hassam's *Late Afternoon, New York: Winter* (cat. no. 47) is typical, and it is also typically American in its emphasis on motion and the implied passage of time. Monet's studies of haystacks in the snow or ice floes on the Seine mark the passage of seasonal or diurnal time in individual and sequential canvases. In contrast, Hassam's painting suggests both present and future: the heavi-

ness of the snowfall and its clearly stated motion herald a further accumulation, perhaps even the day-long storm that New Yorkers anticipate once or twice a year.

Hassam's painting provides a revealing point of comparison to Turner's frightening storm. For many artists of this continent, the faces of winter have been more familiar and consequently less threatening than for residents of milder climates. North Americans take a certain delight in the severity of their winters, a fact that subverts the traditional association of winter and despair. Indeed, for much of the United States and Canada, snow and ice are predictable constants and, like all of life's constants, form the stuff of poetry and nostalgia. The common denominator in paintings like Cropsey's *North Conway* (cat. no. 26) or Durrie's *Gathering Wood for Winter* (cat. no. 25) is the sort of seasonal contentment that made the prints of Currier and Ives the most popular landscapes in the history of American art.

As soon as the seasons are over, they
begin again. . . . All things are preserved
by dying. All things, from their destruction, are restored.
 Tertullian (ca. 160–ca. 230 A.D.)[9]

O God most wise, founder and governor of
the world, at whose behest the seasons
revolve in stated changes, like unto sere
death is Winter, whose desolateness and
hardship are the better borne because soon
to be succeeded by the amenity of Spring.
 Desiderius Erasmus (1466?–1536)[10]

Explicit or implicit in many of the works previously discussed is the notion that winter is a seasonal metaphor for death. While most of nature is only dormant in the winter months, her visual aspects—barren trees, withered vines, the funereal whiteness of snow, the ghostly pallor of the sky—inevitably suggest the death of the earth and, by implication, the death of man. Ancient and medieval literature abounds

[9]Tertullian, *Apologeticus*, English translation from *Apologetical Works and Minucius Felix Octavius*, trans. Sister Emily Joseph Daly (Washington, D.C., 1950), p. 119.
[10]Desiderius Erasmus, "Prayer for Winter," quoted in Roland Bainton, *Erasmus of Christendom* (New York, 1969), p. 245.

in wintry allusions to mortality. Bede, in one of his most memorable metaphors, compares human life to a bird that flies through an open window, is visible for a moment in a warm and fire-lit hall, and then escapes into the night, flying from "dark winter to dark winter."[11] When we speak of "the dead of winter," we echo a long-standing tradition of morbid associations.

In art, these associations can be symbolic or quite literal. Winter as a setting for death receives its boldest expression in nineteenth-century studies of wintry battles and snow-bogged retreats, many of them illustrating the military adventures of Napoleon. Jean-Louis-Ernest Meissonier's painting of Napoleon's campaign of 1814 is perhaps the most famous example of the genre, but the grimmest image is surely Baron Gros's *Battle of Eylau*, in which the emperor is surrounded by the corpses of men who have died on the snow-covered plain. The subject was to be repeated often, as in *The Retreat* of Jean-Baptiste-Edouard Detaille (cat. no. 36), one of Meissonier's pupils. Detaille records an incident in the Franco-Prussian War, a retreat taking place in the snows of a particularly bitter winter. This image of fallen men defeated by both nature and human cruelty is sadly international in scope. On this continent Frederic Remington created an American counterpart in his *Battle of War Bonnet Creek* (fig. 12), in which United States troopers stand triumphant over the bodies of Indian warriors stiffening in the snow. There is a terrible sense of inevitability in such images, as if the whole world were an icy, communal grave into which humanity deposits the victims of its wars. The poet Thomas Campbell expressed it perfectly in a stanza from his *Hohenlinden*: "Few, few shall part where many meet! / The snow shall be their winding sheet, / And every turf beneath their feet / Shall be a soldier's sepulchre."[12]

The stark realism of such paintings is in sharp contrast with another kind of nineteenth-century winterscape in which poetic sublimation is the principal approach. Caspar David Friedrich's *Cloister Graveyard in the Snow* (fig. 13) is the classic example, its barren trees and Gothic ruin echoing age-old references to death and the impermanence of human enterprise. In this as in so many other wintry scenes suggesting death, snow becomes a simile for shroud, and trees and ruined Gothic tracery remind one of the bony corpses depicted on late medieval tombs.

[11] Bede's metaphor is from the second book of his *Ecclesiastical History*, 2:13, published in Bede, *The Miscellaneous Works*, vol. 2, trans. J. A. Gibbs (London, 1891), p. 73.
[12] Thomas Campbell, *The Poetical Works of Thomas Campbell* (London, 1891), p. 73.

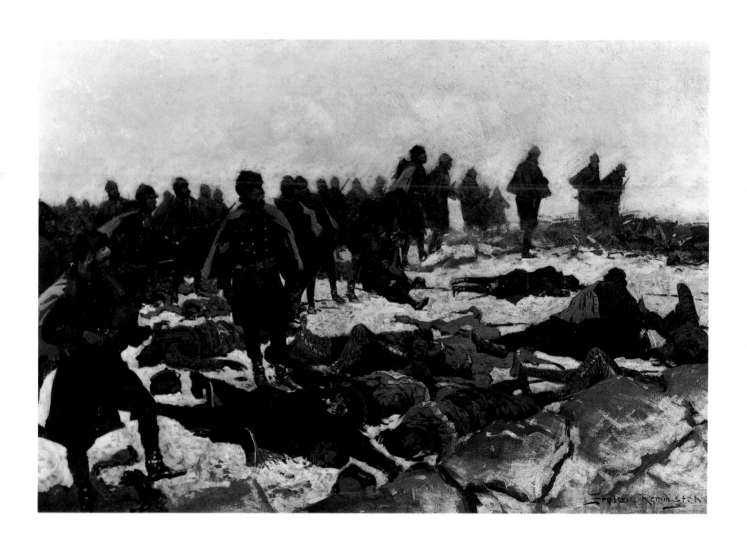

Figure 12. *Frederic Remington, American, 1861-1909*
BATTLE OF WAR BONNET CREEK
Oil on canvas, 26½ × 39 inches
The Thomas Gilcrease Institute of American History and Art, Tulsa, Oklahoma

The dead tree—and many of the trees prominently displayed in such paintings are clearly dead—is one of the most enduring symbols in this tradition. In woodcut and engraved illustrations to Cesare Ripa's *Iconologia*, the Renaissance compendium of symbols and allegories cited earlier in this essay, the personification of winter sits disconsolate beneath a barren tree, and this same dead tree becomes an isolated symbol of winter in other emblematic representations of the year. Whether George Henry Durrie was consciously faithful to this tradition in placing a large, shattered oak in the foreground of his *Gathering Wood for Winter* (cat. no. 25) is an unanswerable question, but the suggestion of mortality is inescapable, just as it is in Grant Wood's *January* (cat. no. 67). In the latter work, the American Regionalist marshals his snow-capped corn shocks like so many hooded mourners on a Burgundian tomb.

If one examines Durrie's painting closely, however, one discovers that the blasted tree is only apparently dead, that there are live shoots springing from its ruined trunk. Regardless of Durrie's intention, this emergence of life from apparent death is a leitmotif running throughout Western attitudes toward winter. Winter gives way to spring, and this seasonal renewal is linked just as inevitably to concepts of rebirth and immortality. From Tertullian's *Apologeticus* to Erasmus's *Winter Prayer*, the medieval Christian world compared the reawakening of nature to the resurrection of the body, as well as to man's rebirth in Baptism and the advent of the Era of Grace. It is the season of spring that realizes and symbolizes this renewal, but winter holds the promise, and the promise is often stated. The labor of February in medieval sculpture and manuscripts is sometimes the pruning of trees, an activity intimately linked to the idea that life springs from death. It is probably no accident that Pieter Bruegel the Elder included this activity in the foreground of his *Adoration of the Magi in the Snow*, for there it can serve both as a labor of the season and as a symbolic reference to the death of the Old Era and the birth of the New.

American artists have been particularly interested in the forward-looking aspects and activities of winter, from Eastman Johnson's *Sugaring Off* (cat. no. 29) and John Henry Twachtman's *End of Winter* (cat. no. 46) to Ernest Lawson's *Spring Thaw* (cat. no. 49). The last of these, incidentally, bears a remarkable resemblance to Monet's famous series of paintings of the breakup of the ice on the Seine (cat. no. 41). In the case of the Monets, however, the "heartbreaking beauty" of the scene (the

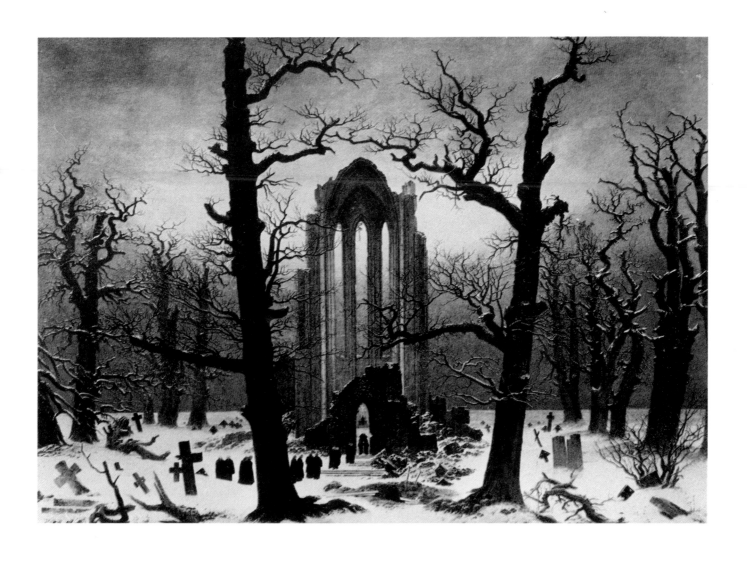

Figure 13. *Caspar David Friedrich, German, 1774-1840*
CLOISTER GRAVEYARD IN THE SNOW, 1817-19

Oil on canvas, approx. 48 × 67 inches
Nationalgalerie, Berlin (destroyed 1945)

words are those of Alice Hoschedé,[13] a friend of Monet) belies the destructive forces of the winter thaw. In 1880, the year in which the series was painted, France experienced a winter of bitter cold and deep snow, and a sudden January thaw brought a terrifying flood of water and ice. This violence of nature reborn, so often apparent in the birth pangs of spring, is the concomitant of the optimism that attends the passing of winter, and it finds its expression in Charles Burchfield's mystical *March Wind* (cat. no. 70), a painting whose aggressive thrust seems to qualify Burchfield's stated belief in the "beneficent God in nature."

The cold moon rising—
Among many withered limbs,
Three shoots of green bamboo.

Freezing wintry wind
Splitting into the rock
The sound of water

Two haiku *by Yosa Buson (1716–1784)*

The Japanese poet and painter Yosa Buson left to his many followers a legacy of both winter *haiku* and winter landscapes. His influence is represented in this exhibition by the hanging scroll by Matsumura Goshun (Gekkei) entitled *The Road to Shu* (cat. no. 5), in which travelers make their way along a steep mountain path amid barren trees and snow-covered precipices. The painting represents a tradition of landscape painting that begins in China and finds some of its earliest and most monumental winter scenes in the work of artists such as Li Cheng (Li Ch'eng). In the Ming dynasty, Shen Zhou (Shen Chou) (cat. no. 1) and Wen Zhengming (Wen Cheng-ming) (cat. no. 2) continue the tradition with winterscapes that evoke the mystical and philosophical roots of Chinese landscape painting. It is interesting that Wen Zhengming is virtually the contemporary of Pieter Bruegel the Elder, for there is a remarkable affinity between Chinese landscapes and those of the sixteenth-century Flemish master, an affinity that reflects not an East-West exchange of artistic concepts (unlikely at this date), but rather certain parallels between the Taoist and Confucian base of Chinese landscape

[13] Alice Hoschedé is quoted in Joel Isaacson, *The Crisis of Impressionism: 1878–1882* (Ann Arbor, 1980), p. 133.

painting and the pantheistic and neo-Stoic overtones of Bruegel's works. In both traditions, the laws of nature and the eternal cycle of the seasons serve as the context for human activity perfectly integrated with the life of the earth.

Bruegel also would have appreciated the Japanese landscapes of later generations. Yokoi Kinkoku (cat. nos. 6–8), another follower of Buson, created winter scenes as intimate as Bruegel's *Adoration*; and by spattering the surface of his paintings with white ink (a technique rare but not unknown in Chinese painting), he created the same effect of softly falling snow. In style, however, Kinkoku's paintings are more akin to those of the Impressionists, with their swift, spontaneous rendering of landscape details. In fact, the poem that Kinkoku inscribed on one of the paintings in this exhibition could just as easily serve as an inscription for Pissarro's *Piette's House at Montfoucault* (cat. no. 40): "The World has a new kind of jeweled tree; / Half a step out of the door and I feel the cold wind."[14]

That cold wind also chills the observer of Utagawa Kuniyoshi's woodcut of a woman in the snow (cat. no. 9), a figure that recalls the bundled personifications of winter in ancient and medieval art of the West. While such comparisons may be of no art-historical consequence—we deal here with coincidence and not influence—such parallels underscore the universal theme running through almost all of the works in this exhibition: the idea that this most hostile of seasons demands a human accommodation that can be elegant in its success, tragic in its failure, and as constant in its necessity as the facts of life and death.

BIBLIOGRAPHICAL NOTE

In addition to the sources cited in the footnotes, the following works may be of interest to the general reader.

Grossman, Fritz. *Pieter Bruegel the Elder: Complete Edition of the Paintings.* London, 1973. This study includes reproductions and analyses of Bruegel's winter scenes.

Hutson, Martha. *George Henry Durrie.* Laguna Beach, 1977. This scholarly study of the American landscape painter includes a comprehensive introduction to the subject of winter in American art.

[14] The translation is by Jonathan Chaves, quoted in Stephen Addiss, *Zenga and Nanga, Paintings by Japanese Monks and Scholars* (New Orleans, 1976), p. 124. The two *haiku* by Buson that introduce the last section of this essay are transcribed and translated in Calvin French, *The Poet-Painters: Buson and his Followers* (Ann Arbor, 1974), pp. 71, 78.

Lee, Sherman. *Chinese Landscape Painting*. London, 1962. A good introduction to the subject, this work includes a number of major winterscapes and a discussion of the philosophical bases of Chinese landscape painting.

Nasgaard, Roald. *The Mystic North: Symbolist Landscape Painting in Northern Europe and North America 1890–1940*. Toronto, 1984. This catalogue of the memorable exhibition of landscape painting at the Art Gallery of Ontario contains a thorough analysis of the philosophical and psychological foundation of its subject.

Stechow, Wolfgang. *Dutch Landscape Painting of the Seventeenth Century*. London, 1966. The work includes a history of the winter landscape in Dutch art and its antecedents in fifteenth- and sixteenth-century northern painting.

CATALOGUE
OF THE EXHIBITION

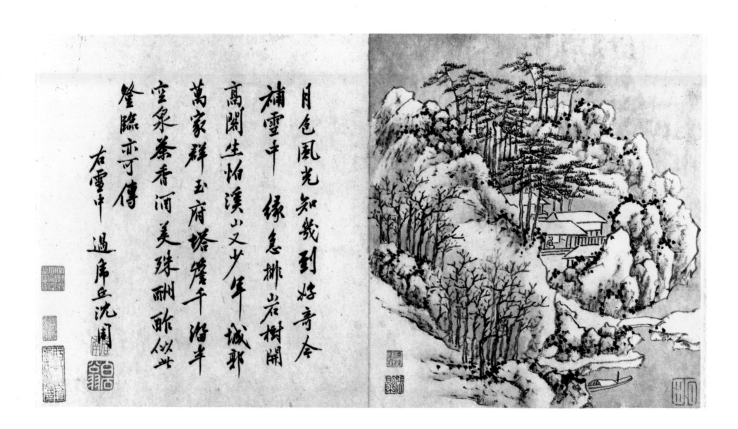

1. *Shen Zhou (Shen Chou), Chinese, 1427–1509*

SNOW SCENE *with calligraphy and poem by the artist, from* SCENES OF SUZHOU
AND VICINITIES, *between 1484 and 1504*

Ink and light color on paper, album leaf, 13⅜ × 23⁵⁄₁₆ inches
Collection of Mr. and Mrs. Wan-go H. C. Weng

2. *Wen Zhengming (Wen Cheng-ming), Chinese, 1470–1559*

SNOW SCENE *with calligraphy and poem by the artist, from* EIGHT SCENES OF XIAO XIANG

Ink and light color on paper, album leaf, 8¹¹/₁₆ × 8⅛ inches; calligraphy 9¹/₁₆ × 8⁷/₁₆ inches
Collection of Mr. and Mrs. Wan-go H. C. Weng

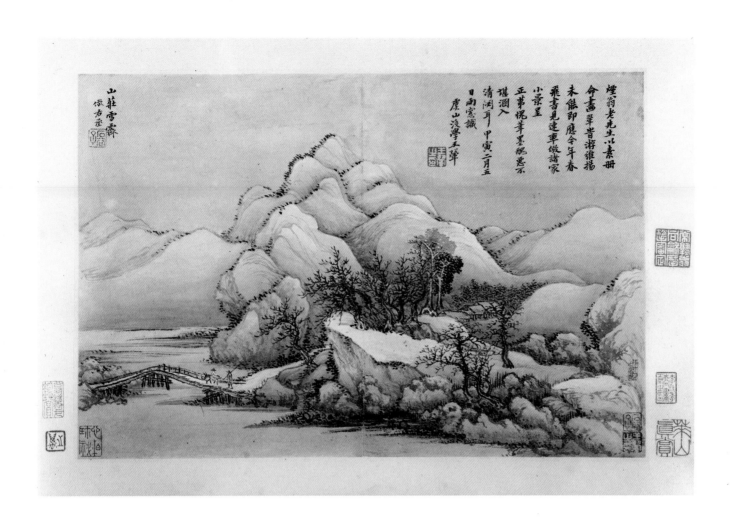

3. *Wang Hui, Chinese, 1632–1717*

WINTER SCENE *from* LANDSCAPES AFTER ANCIENTS, *1674*

Ink and light color on paper, album leaf, 8¹¹⁄₁₆ × 13¼ inches
Collection of Mr. and Mrs. Wan-go H. C. Weng

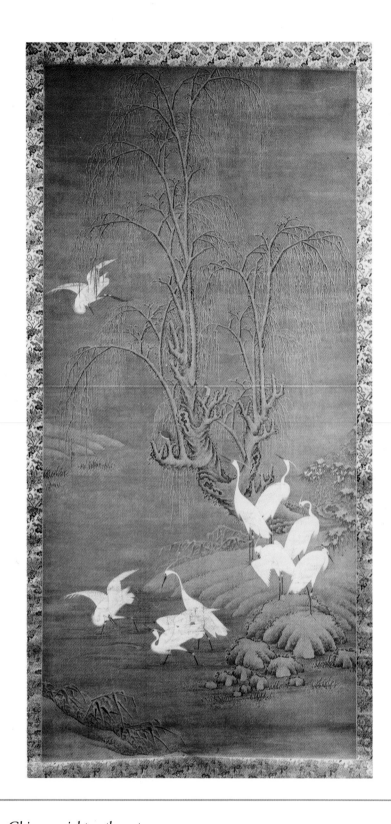

4. *Unknown, Chinese, eighteenth century*

NINE EGRETS IN A SNOWY LANDSCAPE

Ink and light color on silk, hanging scroll, 51 × 24 inches
Hood Museum of Art, Dartmouth College, Gift of Mr. and Mrs. D. Herbert Beskind, Class of 1936

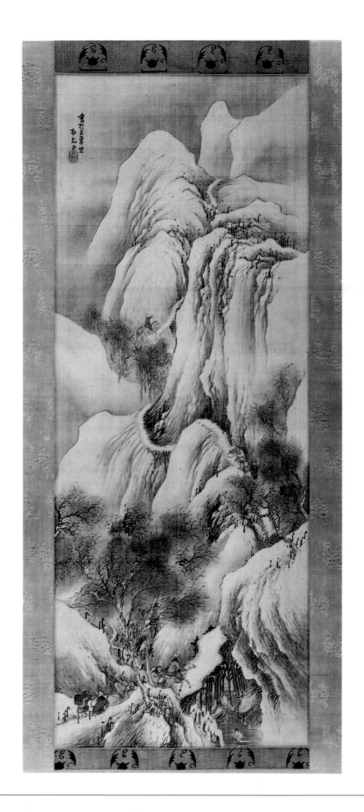

5. *Matsumura Goshun (Gekkei), Japanese, Edo period, 1752–1811*

THE ROAD TO SHU, *ca. 1780–81*

Ink and color on silk, hanging scroll, 50⅝ × 19¾ inches
The University of Michigan Museum of Art, Margaret Watson Parker Art Collection, 1970/2.152

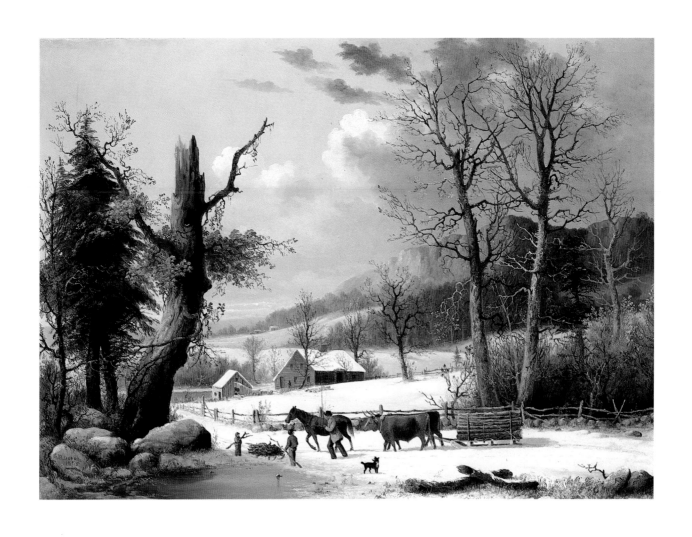

25. *George Henry Durrie, American, 1820–1863*

GATHERING WOOD FOR WINTER, *1855*

Oil on canvas, 26 × 36 inches
Collection of William Nathaniel Banks

26. *Jasper Francis Cropsey, American, 1823–1900*

WINTER LANDSCAPE, NORTH CONWAY, N.H., *1859*

Oil on canvas, 10¼ × 16½ inches
Collection of Henry Melville Fuller

27. *George Henry Durrie, American, 1820–1863*

SKATING ON THE CONNECTICUT RIVER, *1862*

Oil on canvas, 24⅛ × 32 inches
Anonymous Lender

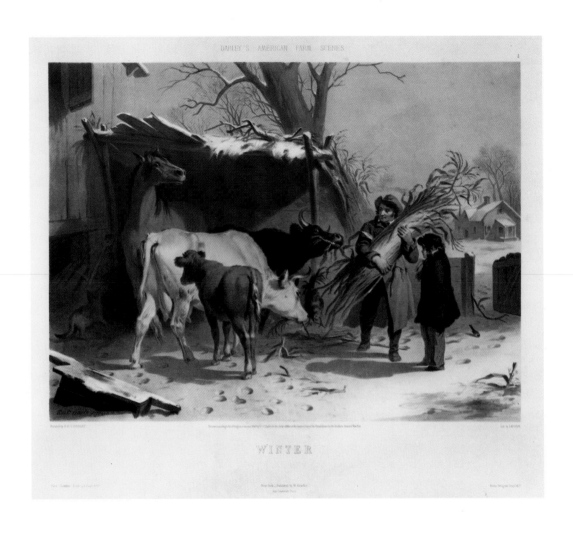

28. *Jean-Baptiste-Adolphe Lafosse, French, 1810–1879, after Felix Octavius Carr Darley,*
 American, 1822–1888

WINTER, *from* DARLEY'S AMERICAN FARM SERIES, *1860*

Color lithograph, 13¼ × 18½ inches
Hood Museum of Art, Dartmouth College, Whittier Fund

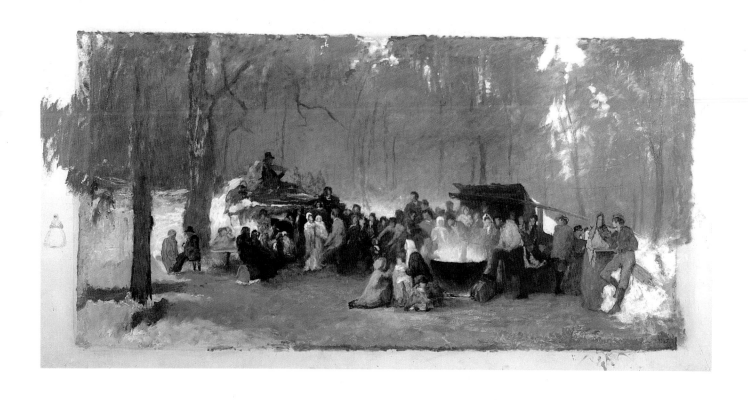

29. *Eastman Johnson, American, 1824–1906*

SUGARING OFF, *ca. 1861–66*

Oil on canvas, 52¾ × 96½ inches
Museum of Art, Rhode Island School of Design, Museum Works of Art Fund

30. *George Inness, American, 1825–1894*

CHRISTMAS EVE, *1866*

Oil on canvas, 22 × 30 inches
Montclair Art Museum, Montclair, New Jersey, Museum Purchase, 1948

31. *Frederic Edwin Church, American, 1826–1900*

WINTER LANDSCAPE FROM OLANA, *1870–71*

Oil on paper mounted on composition board, 11¾ × 18¼ inches
New York State Office of Parks, Recreation and Historic Preservation, Bureau of Historic Sites, Olana State Historic Site,
 Taconic Region

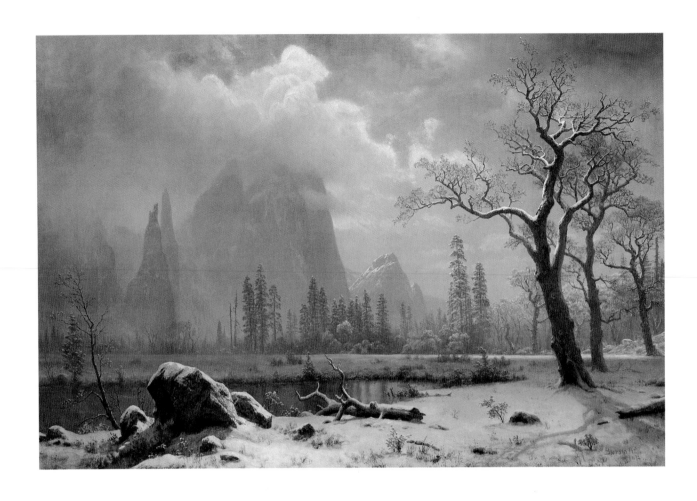

32. *Albert Bierstadt, American, 1830–1902*

YOSEMITE WINTER SCENE, *1872*

Oil on canvas, 32⅛ × 48⅛ inches
University Art Museum, University of California, Berkeley, Gift of Henry D. Bacon

33. *William Formby Halsall, American, born England, 1841–1919*

SUMMIT OF MOUNT WASHINGTON IN WINTER, *1889*

Oil on canvas, 19 × 27 inches
Littleton Public Library, Littleton, New Hampshire

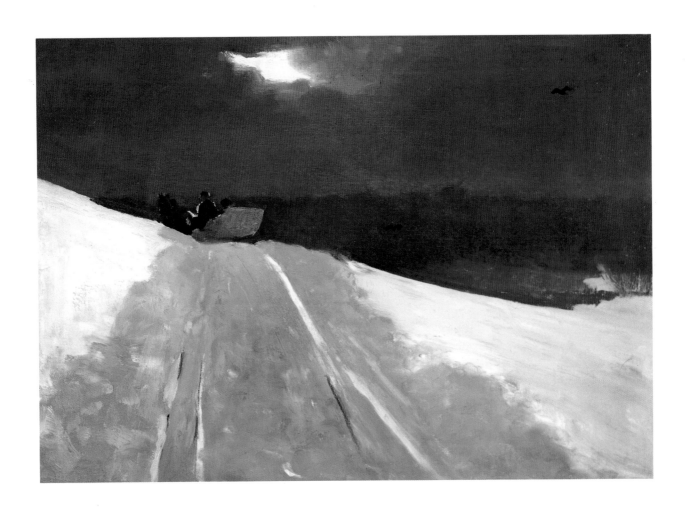

34. *Winslow Homer, American, 1836–1910*

SLEIGH RIDE, *ca. 1893*

Oil on canvas, 14¹⁄₁₆ × 20¹⁄₁₆ inches
Sterling and Francine Clark Art Institute, Williamstown, Massachusetts

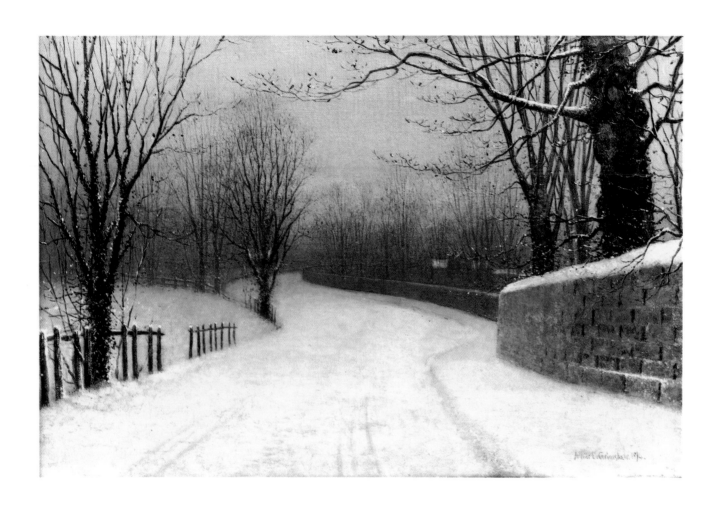

35. *Arthur E. Grimshaw, English, 1868–1913*

A WINTER LANE, *1894*

Oil on canvas, 18 × 11¾ inches
Collection of Mr. and Mrs. Peter Heydon, Ann Arbor, Michigan

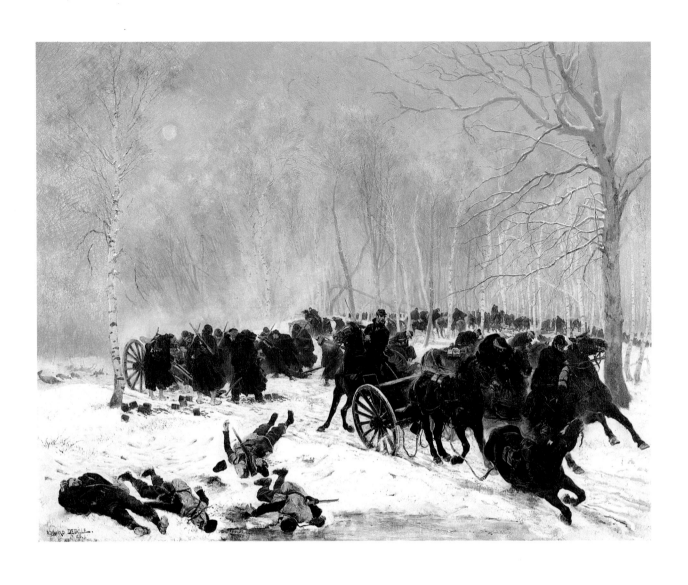

36. *Jean-Baptiste-Edouard Detaille, French, 1848–1912*

THE RETREAT, *or* FRENCH ARTILLERY, *1873*

Oil on canvas, 49 × 63 inches
John and Mable Ringling Museum of Art

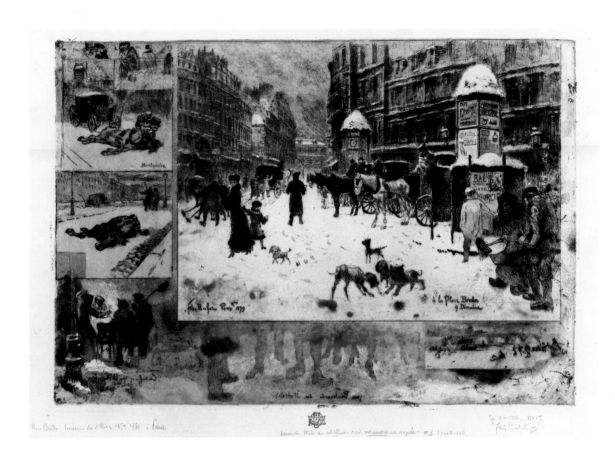

37. *Félix-Hilaire Buhot, French, 1847–1898*

WINTER IN PARIS, *or* PARIS IN THE SNOW, *1879–80*

Etching, aquatint, soft-ground, drypoint, and roulette on greenish laid paper; third state of nine, artist's proof before publication,
9⅜ × 13¾ inches
Collection of Carol and James Goodfriend

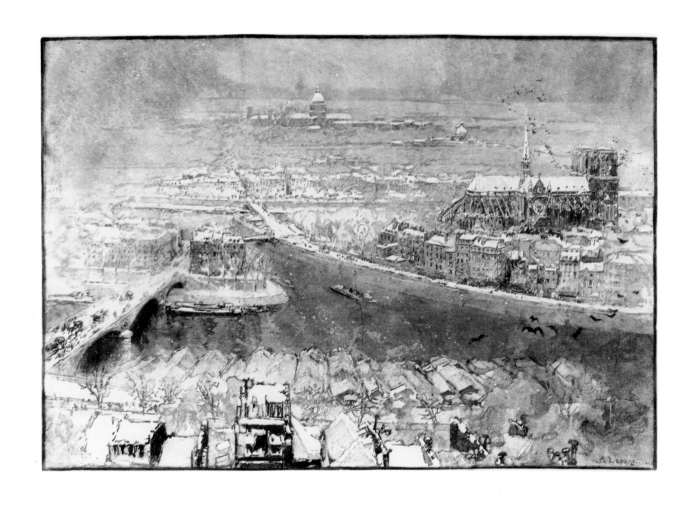

38. *Louis-Auguste Lepère, French, 1849–1918*

PARIS IN THE SNOW, MORNING OF MARCH I, 1890, FROM THE TOWER OF
SAINT-GERVAIS, *1890*

Wood engraving, 11⅞ × 17½ inches
Collection of Carol and James Goodfriend

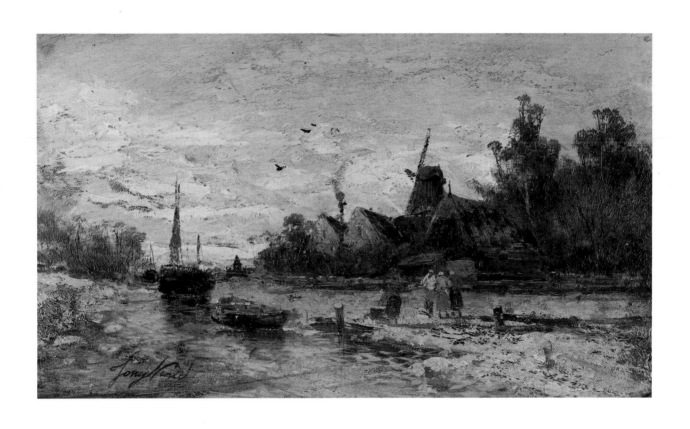

39. *Jean-Barthold Jongkind, Dutch, 1819–1891*

WINTER SCENE, *ca. 1865*

Oil on panel, 7⅛ × 12⅜ inches
The Kempe Collection

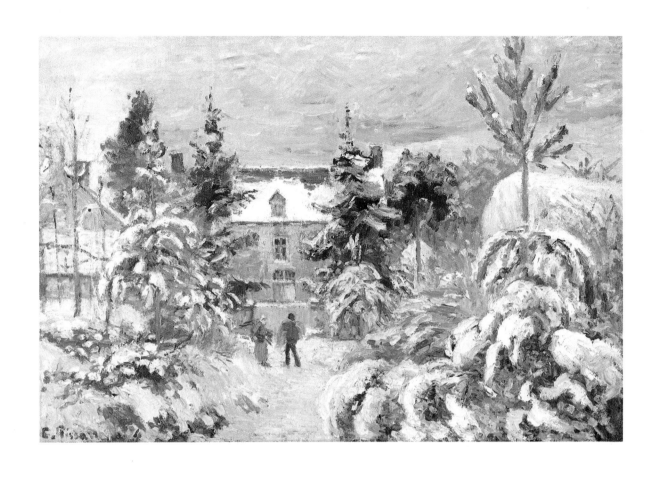

40. *Camille Pissarro, French, 1830–1903*

PIETTE'S HOUSE AT MONTFOUCAULT (SNOW), *1874*

Oil on canvas, 18⅛ × 26⅝ inches
Sterling and Francine Clark Art Institute, Williamstown, Massachusetts

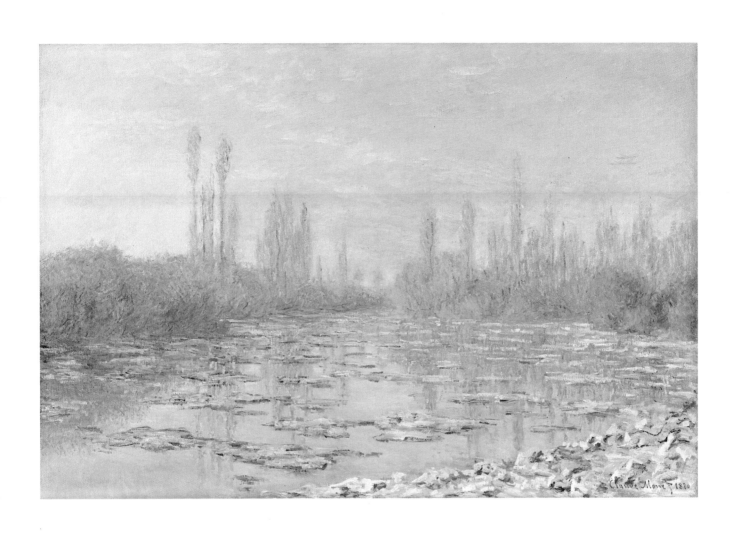

41. *Claude Monet, French, 1840–1926*

THE FLOATING ICE, *1880*

Oil on canvas, 38¼ × 58¼ inches
Shelburne Museum, Shelburne, Vermont

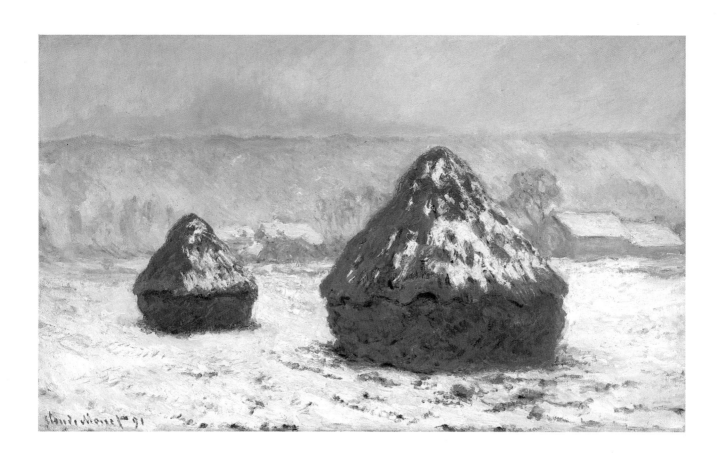

42. *Claude Monet, French, 1840–1926*

HAYSTACKS IN THE SNOW, *1891*

Oil on canvas, 23½ × 39½ inches
Shelburne Museum, Shelburne, Vermont

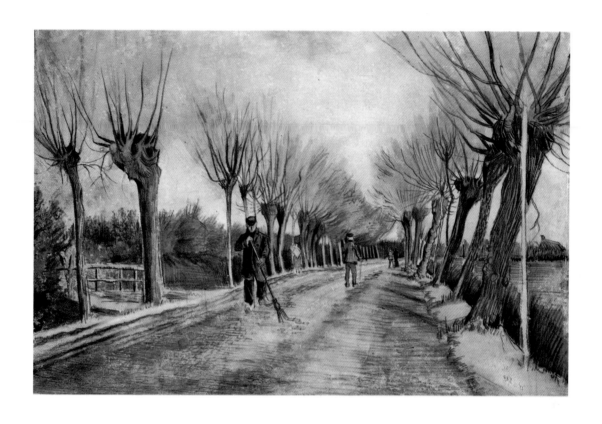

43. *Vincent van Gogh, Dutch, 1853–1890*

ROAD NEAR NUENEN, *1881*

Chalk, pencil, pastel, and watercolor, 15½ × 22¾ inches
The Metropolitan Museum of Art, Robert Lehman Collection, 1975 (1975.1.774)

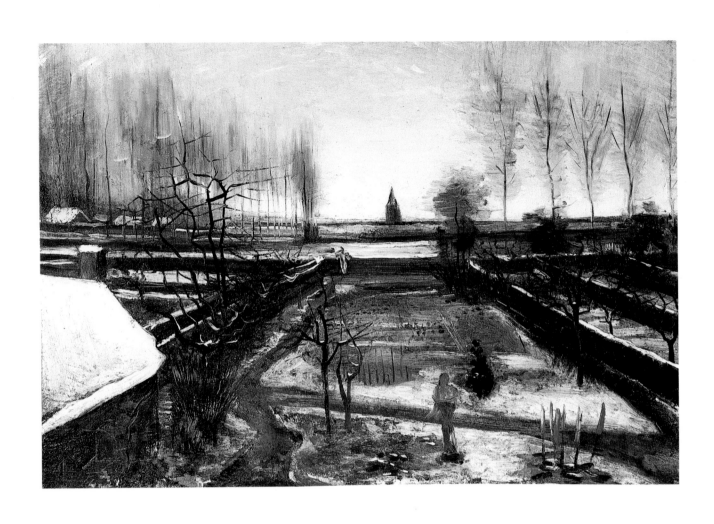

44. *Vincent van Gogh, Dutch, 1853–1890*

GARDEN OF THE RECTORY AT NUENEN, *1885*

Oil on canvas, mounted on panel, 20⅞ × 30¾ inches
The Armand Hammer Foundation

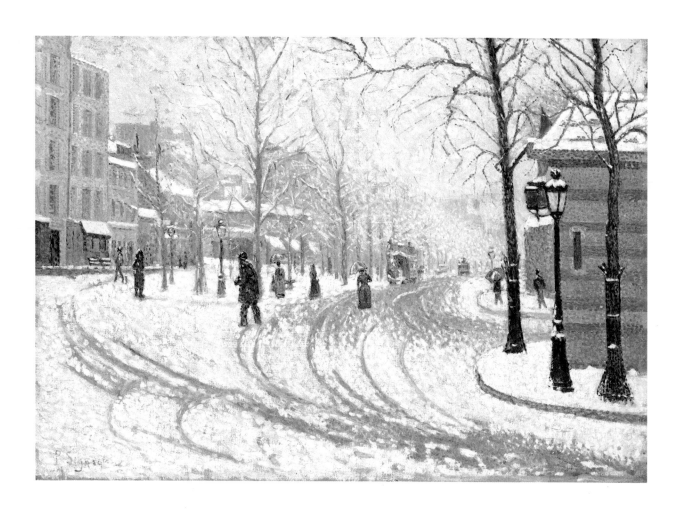

45. *Paul Signac, French, 1863–1935*

BOULEVARD DE CLICHY, *1886*

Oil on canvas, 18⁵/₁₆ × 25¹³/₁₆ inches
The Minneapolis Institute of Arts, Bequest of Putnam Dana McMillan

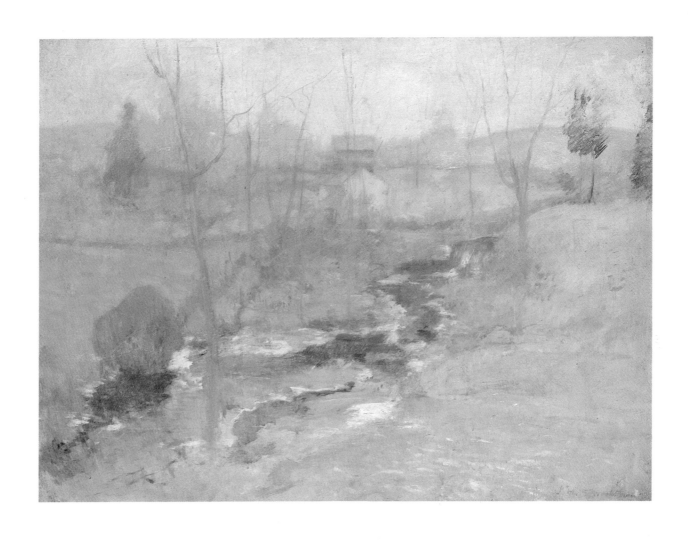

46. *John Henry Twachtman, American, 1853–1902*

END OF WINTER, *after 1889*

Oil on canvas, 22 × 30⅛ inches
National Museum of American Art, Smithsonian Institution, Gift of William T. Evans

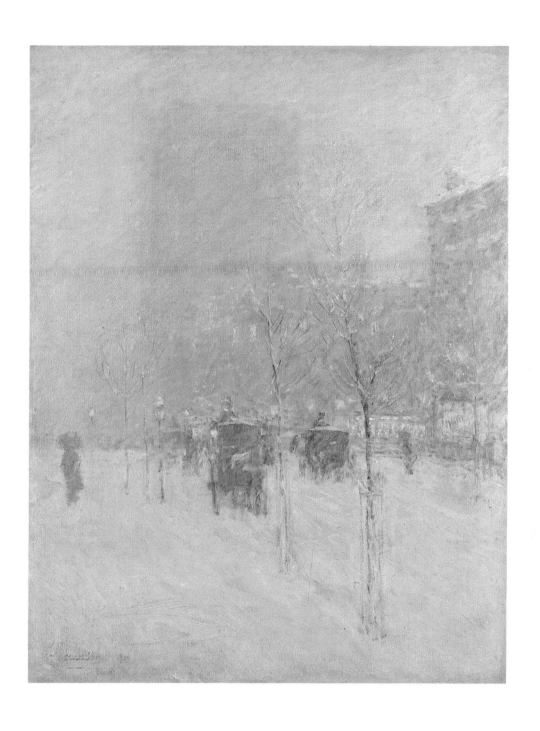

47. *Childe Hassam, American, 1859–1935*

LATE AFTERNOON, NEW YORK: WINTER, *1900*

Oil on canvas, 37¼ × 29⅛ inches
The Brooklyn Museum, Dick S. Ramsay Fund

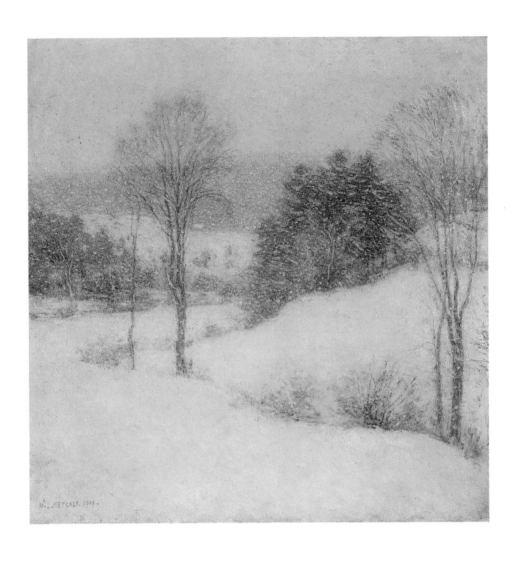

48. *Willard L. Metcalf, American, 1858–1925*

THE WHITE VEIL, *1909*

Oil on canvas, 24 × 24 inches
Museum of Art, Rhode Island School of Design, Gift of Mrs. Gustav Radeke

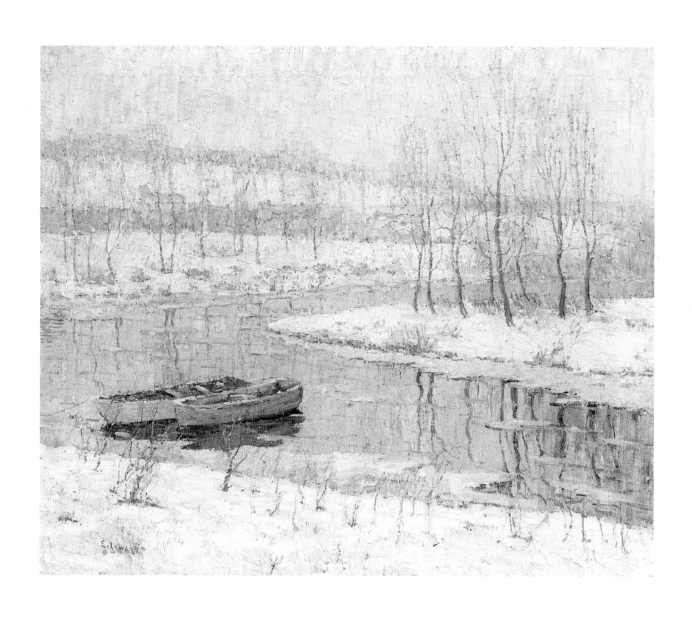

49. *Ernest Lawson, American, 1873–1939*

SPRING THAW

Oil on canvas, 25 × 30 inches
Daniel J. Terra Collection, Terra Museum of American Art, Evanston, Illinois

50. *Lilian Westcott Hale, American, 1881–1963*

BLIGHTED HOPE

Charcoal and crayon on paper, 28¾ × 23¾ inches
Collection of Mr. and Mrs. Peter Heydon, Ann Arbor, Michigan

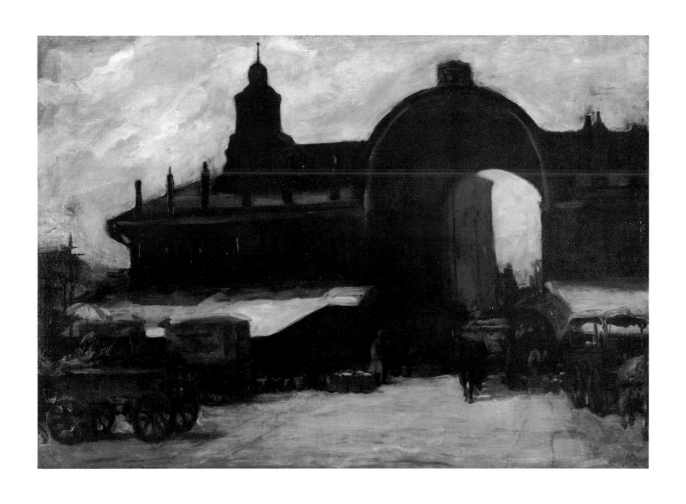

51. *John Sloan, American, 1871–1951*

DOCK STREET MARKET, *ca. 1902*

Oil on canvas, 24 × 36 inches
Montgomery Museum of Fine Arts, Montgomery, Alabama, Montgomery Museum of Fine Arts Association Purchase

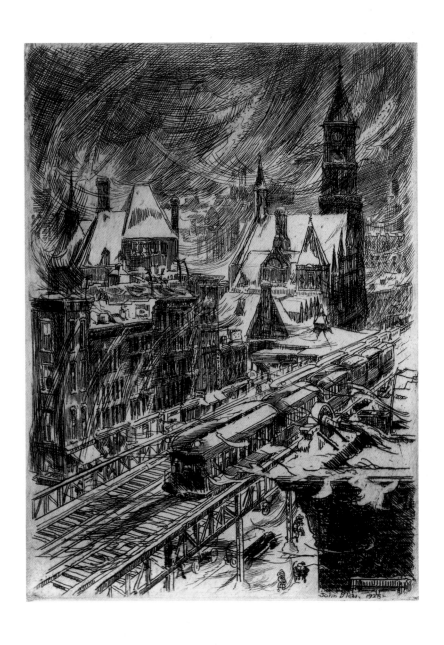

52. *John Sloan, American, 1871–1951*

SNOWSTORM IN THE VILLAGE, *1925*

Etching, 7 × 5 inches
Bowdoin College Museum of Art, Brunswick, Maine

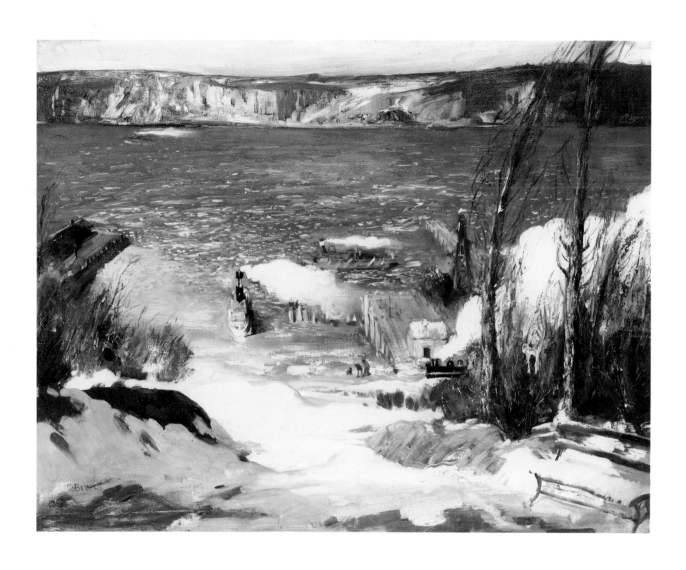

53. *George Bellows, American, 1882–1925*

NORTH RIVER, *1908*

Oil on canvas, 32¾ × 42¾ inches
The Pennsylvania Academy of the Fine Arts, Temple Fund Purchase

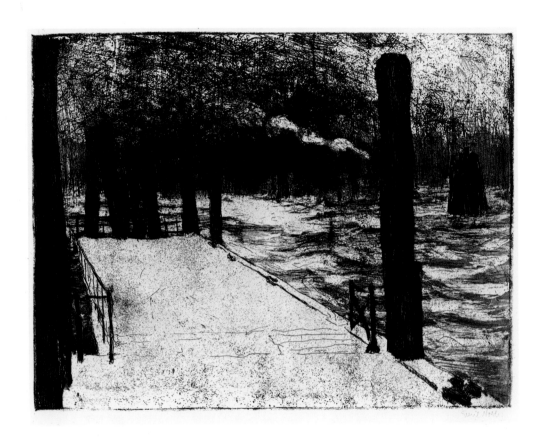

54. *Emil Hansen Nolde, German, 1867–1956*

LANDING PIER, HAMBURG, *1910*

Etching and aquatint, 12 × 15¹⁵/₁₆ inches
The Detroit Institute of Arts, City of Detroit Purchase

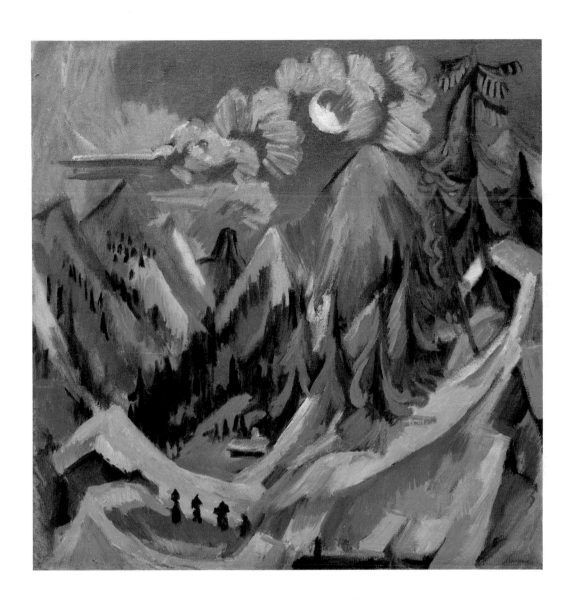

55. *Ernst Ludwig Kirchner, German, 1880–1938*

WINTER LANDSCAPE IN MOONLIGHT, *1919*

Oil on canvas, 47½ × 47½ inches
The Detroit Institute of Arts, Gift of Curt Valentin in memory of the artist

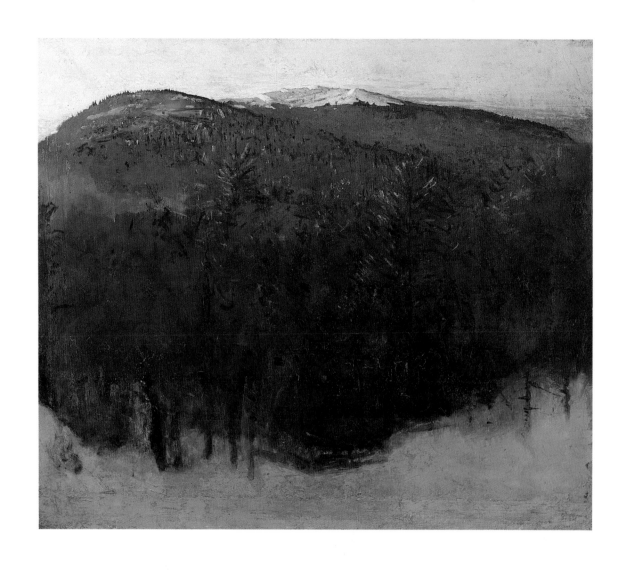

56. *Abbott Handerson Thayer, American, 1849–1921*

SUNRISE ON MOUNT MONADNOCK, NEW HAMPSHIRE, *1919*

Oil on canvas, 52³⁄₈ × 62³⁄₁₆ inches
The Art Museum, Princeton University, Gift of Frank Jewett Mather, Jr.

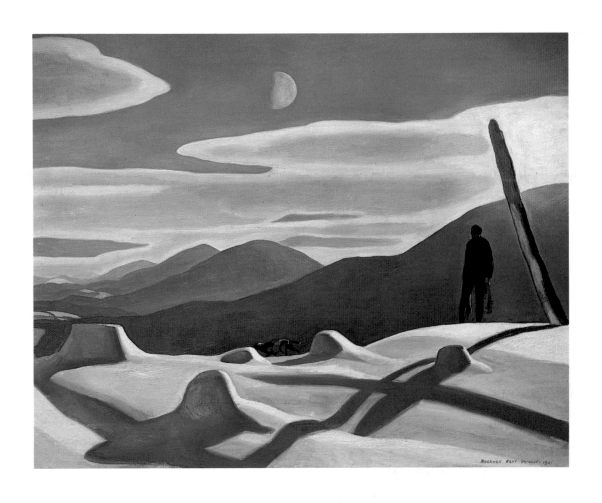

57. *Rockwell Kent, American, 1882–1971*

THE TRAPPER, *1921*

Oil on canvas, 34 × 44 inches
Whitney Museum of American Art, New York, Purchase, 1931, 31.258

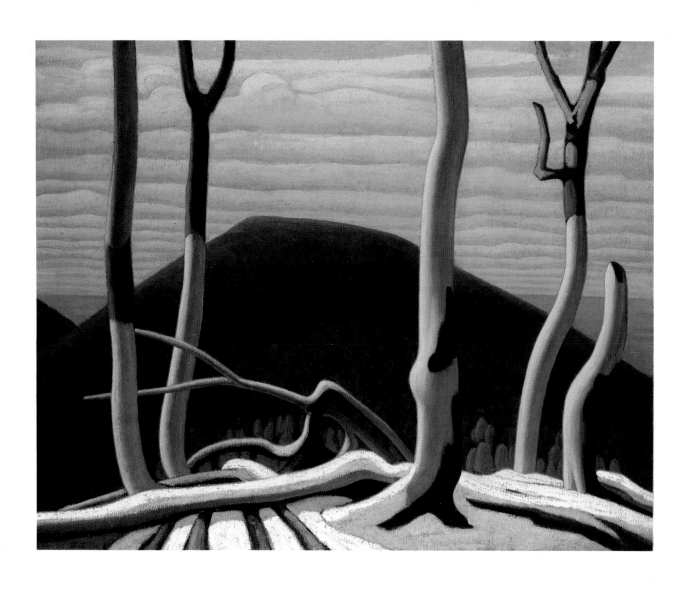

58. *Lawren Harris, Canadian, 1885–1970*

ABOVE LAKE SUPERIOR, *ca. 1922*

Oil on canvas, 48 × 60 inches
Art Gallery of Ontario, Gift from the Reuben and Kate Leonard Memorial Fund, 1929

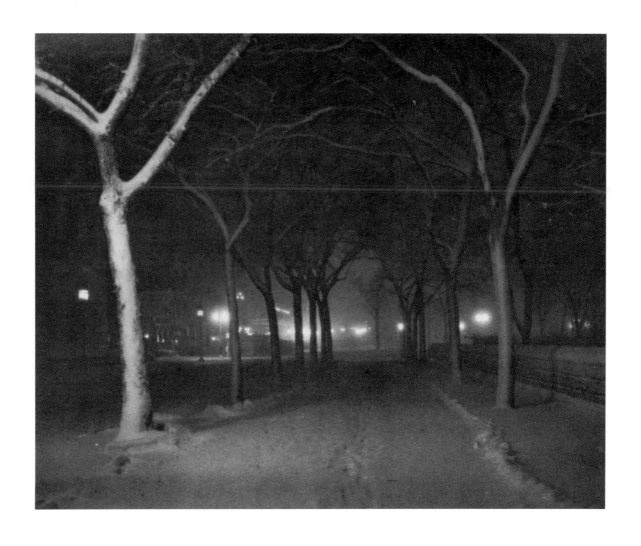

77. *Alfred Stieglitz, American, 1864–1946*

ICY NIGHT, *1898*

Photogravure, 4⅞ × 6¹⁄₁₆ inches
Hood Museum of Art, Dartmouth College, Extended loan

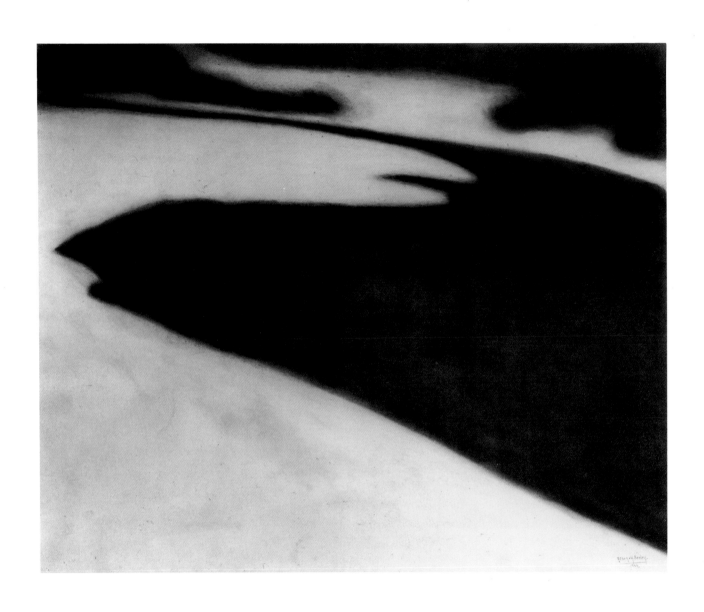

78. *George Seeley, American, 1880–1955*

WINTER LANDSCAPE, *1909*

Gum bichromate and platinum print, 17¼ × 21¼ inches
Gilman Paper Company Collection

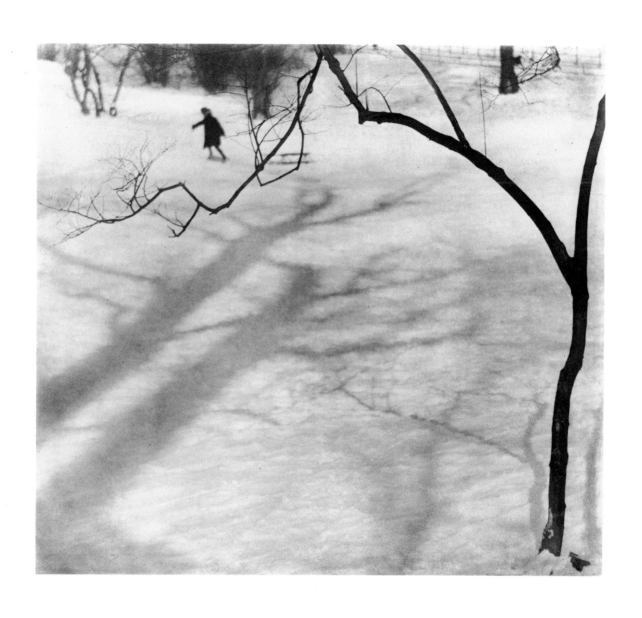

79. *Paul Strand, American, 1864–1976*

WINTER, CENTRAL PARK, NEW YORK, *ca. 1915*

Platinum print, 10 × 11 inches
Gilman Paper Company Collection

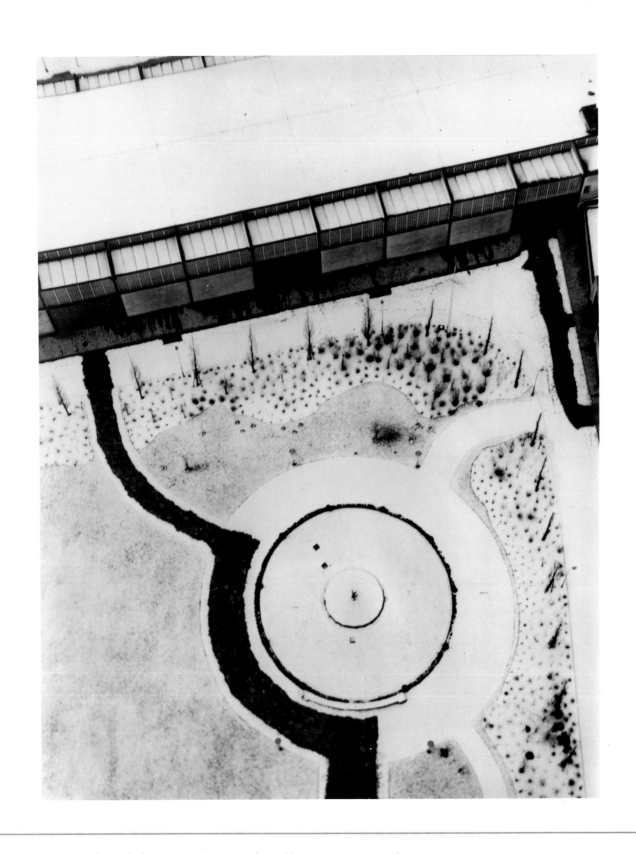

80. *Lazlo Moholy-Nagy, American, born Hungary, 1895–1946*

FROM THE RADIO TOWER, BERLIN, *1928*

Silver print, 10 × 7¾ inches
Gilman Paper Company Collection

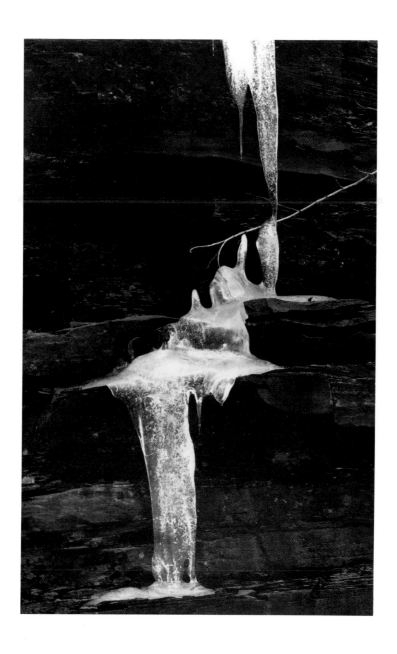

81. *Minor White, American, 1908–1976*

WATKINS GLEN, NEW YORK, *1963*

Silver print, 9⅛ × 5⅞ inches

Hood Museum of Art, Dartmouth College, Extended loan. Reproduction courtesy of the Minor White Archive, Princeton University.
 Copyright © 1985 The Trustees of Princeton University

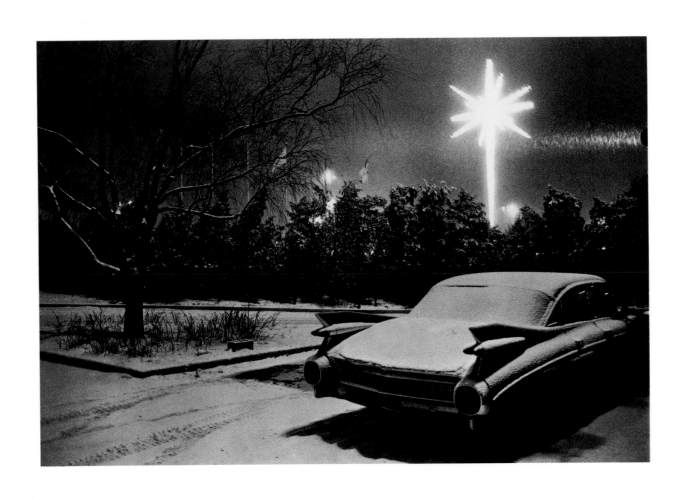

82. *Joel Meyerowitz, American, born 1938*

CHRISTMAS, KENNEDY AIRPORT, *1967*

Gelatin-silver print, 9 × 13½ inches
The Museum of Modern Art, New York, Purchase

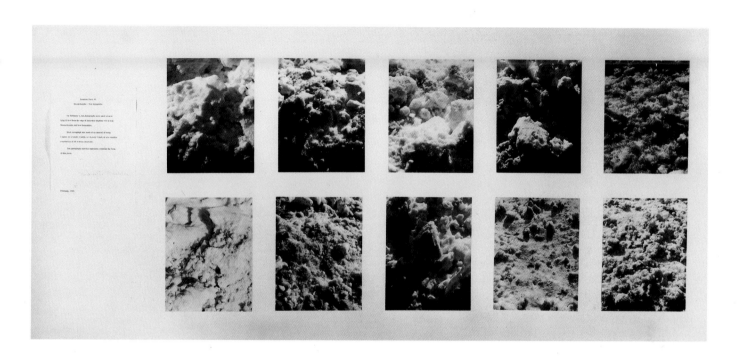

The description reads as follows:

Location Piece #5
Massachusetts – New Hampshire
On February 7, ten photographs were made of snow
lying 12 feet from the edge of Interstate Highway 495 in both
Massachusetts and New Hampshire.
 Each photograph was made at an interval of every
5 miles; or of every 5 yards; or of every 5 feet; or of a variable
combination of all of those intervals.
 Ten photographs and this statement constitute the form
of this piece.

February, 1969

83. *Douglas Huebler, American, born 1924*

LOCATION PIECE #5 MASSACHUSETTS–NEW HAMPSHIRE, *1969*

Ten silver prints, each 9¼ × 7¼ inches
Gilman Paper Company Collection

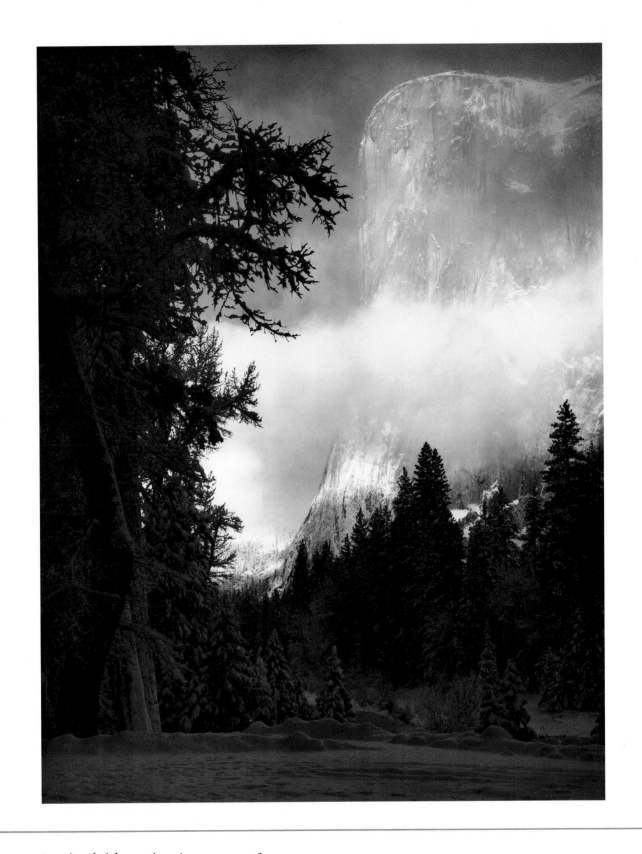

84. *Ansel Adams, American, 1902–1984*

EL CAPITAN, SUNRISE, WINTER, YOSEMITE VALLEY, CALIFORNIA, *ca. 1968,*
 from PORTFOLIO VII, *1976*

Silver print, 19¼ × 15⅜ inches

Hood Museum of Art, Dartmouth College, Extended loan. Reproduction courtesy of the Ansel Adams
 Publishing Rights Trust. All rights reserved

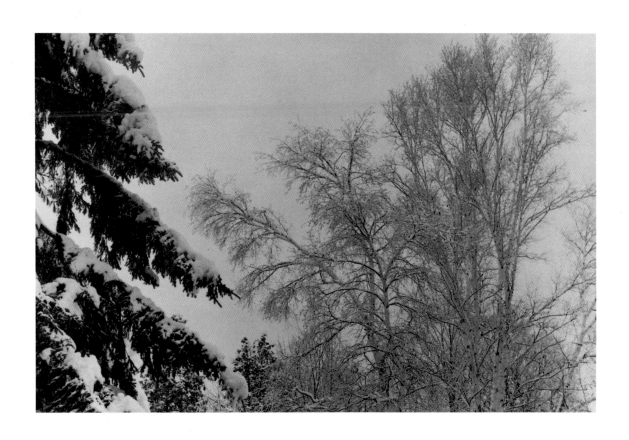

85. *Ralph Steiner, American, born 1899*

UNTITLED, *ca. 1970*

Silver print, 4¼ × 6½ inches
Collection of Ralph Steiner, Dartmouth College Class of 1921

PHOTO CREDITS

INDEX OF ARTISTS

Lafosse, Jean-Baptiste-Adolphe, 76; *Winter*, 76 (illus.)

Lawson, Ernest, 42, 97; *Spring Thaw*, 42, 97 (illus.)

Leighton, Clare, 113; *Landing*, 113

Lepère, Louis-Auguste, 86; *Paris in the Snow, Morning of March 1, 1890, from the Tower of Saint-Gervais*, 86 (illus.)

Lewis, Martin, 110; *White Monday*, 110 (illus.)

Li Cheng (Li Ch'eng), 44

Limbourg Brothers, 20, 21, 32; *December*, 24, 25 (illus.); *February*, 20, 21 (illus.); *Les Très Riches Heures du Duc de Berry*, 20, 21, 22, 24, 26, 32

Limbourg, Pol, 32

Lozowick, Louis, 111; *White Mansions*, 111 (illus.)

Matsumura Goshun (Gekkei), 44, 53; *The Road to Shu*, 44, 53 (illus.)

Meissonier, Jean-Louis-Ernest, 40

Metcalf, Willard L., 36, 96; *The White Veil*, 36, 96 (illus.)

Meyerowitz, Joel, 130; *Christmas, Kennedy Airport*, 130 (illus.)

Milton, Peter, 120; *Sanctuary's Edge*, 120 (illus.)

Moholy-Nagy, Lazlo, 128; *From the Radio Tower, Berlin*, 128 (illus.)

Molijn, Pieter, 66; *Winter Landscape*, 66 (illus.)

Monet, Claude, 38, 42, 44, 89, 90; *The Floating Ice*, 38, 42, 89 (illus.); *Haystacks in the Snow*, 38, 90 (illus.)

Morland, George, 67; *Winter Landscape*, 67 (illus.)

Mount, William Sidney, 24, 71; *Catching Rabbits (Boys Trapping)*, 24, 71

Nolde, Emil Hansen, 102; *Landing Pier, Hamburg*, 102 (illus.)

O'Keeffe, Georgia, 109; *Barn with Snow*, 109 (illus.)

Pissarro, Camille, 38, 45, 88; *Piette's House at Montfoucault (Snow)*, 38, 45, 88 (illus.)

Poussin, Nicolas, 36; *Deluge*, 36; *Four Seasons*, 36

Prior, William Matthew, 70; *In with the Sleigh*, 70 (illus.) (attribution)

Remington, Frederic, 40, 41; *Battle of War Bonnet Creek*, 40, 41 (illus.)

Ruisdael, Jacob van, 33, 34, 35; *Winter Landscape with a Windmill*, 34 (illus.), 35

Saenredam, Jan, 64; *Winter*, 26, 64 (illus.)

Sample, Paul, 114; *Lamentations V: 18 (Fox Hunt)*, 114 (illus.)

Seeley, George, 126; *Winter Landscape*, 126 (illus.)

Shen Zhou (Shen Chou), 44, 49; *Snow Scene*, 49 (illus.)

Shoson Ohara-Matao, 60; *Nanten Bush and Fly Catchers in the Snow*, 60 (illus.)

Signac, Paul, 36, 38, 93; *Boulevard de Clichy*, 36, 38, 93 (illus.)

Sisley, Alfred, 38

Sloan, John, 99, 100; *Dock Street Market*, 99 (illus.); *Snowstorm in the Village*, 100 (illus.)

Steiner, Ralph, 33, 133; *Untitled*, 133 (illus.)

Stieglitz, Alfred, 123, 124, 125; *The Flatiron Building*, 124 (illus.); *Icy Night*, 125 (illus.); *The Street—Design for a Poster*, 123 (illus.)

Strand, Paul, 127; *Winter, Central Park, New York*, 127 (illus.)

Stuart, Gilbert, 30–32; *The Skater (Portrait of William Grant)*, 30, 31 (illus.), 32

Sully, Thomas, 69; *Skater*, 30, 69 (illus.)

Thayer, Abbott Handerson, 104; *Sunrise on Mount Monadnock, New Hampshire*, 104 (illus.)

Turner, Joseph Mallord William, 36, 37, 38; *Valley of Aosta—Snowstorm, Avalanche and Thunderstorm*, 36, 37 (illus.)

Twachtman, John Henry, 33, 42, 94; *End of Winter*, 42, 94 (illus.)

Unknown, Chinese: *Nine Egrets in a Snowy Landscape*, 52 (illus.)

Unknown, Dutch: *Untitled (Ludwina Falling on Ice)*, 26, 28, 61

Unknown, Roman: *Front of a Child's Season Sarcophagus of the Asiatic Columnar Type*, 20, 22 (illus.)

Utagawa (Andō) Hiroshige, 58, 59; *Hodogaya*, 59 (illus.); *Kambara, Night Snow*, 58 (illus.)

Utagawa Kuniyoshi, 45, 57; *Black Turban*, 45, 57 (illus.)

Van der Neer, Aert, 28, 33

Vinckboons, David, 65. *See also* Gerrytsz, Hessel

Wang Hui, 51; *Winter Scene*, 51 (illus.)

Welliver, Neil, 119; *Winter Stream*, 119 (illus.)

Wen Zhengming (Wen Cheng-ming), 44, 50; *Snow Scene*, 50 (illus.)

White, Minor, 129; *Watkins Glen, New York*, 129 (illus.)

Wood, Grant, 42, 115; *January*, 42, 115 (illus.)

Yokoi Kinkoku, 45, 54, 55, 56; *Winter Landscape*, 54 (illus.); *Winter Landscape*, 55 (illus.); *Winter Landscape*, 56 (illus.)

Yosa Buson, 44. *See also* Yosa Buson, School of; Matsumura Goshun (Gekkei); *and* Yokoi Kinkoku

Yosa Buson, School of, 44, 45